ALIEN ART

EXTRATERRESTRIAL EXPRESSIONS ON EARTH

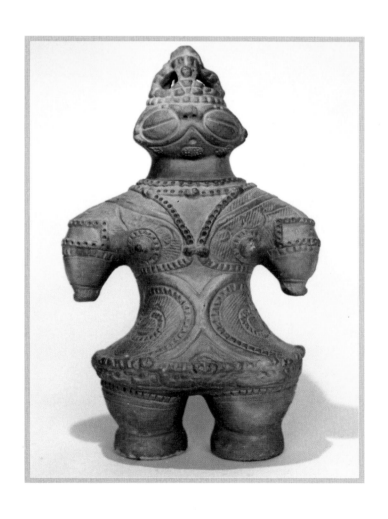

5085 Alien Art
Published in 1998 by CLB International, an imprint of
Quadrillion Publishing Ltd, Godalming Business Centre,
Woolsack Way, Godalming, Surrey GU7 1XW, England

Distributed in the US by Quadrillion Publishing Inc., 230 Fifth Avenue, NY, NY 10001

ISBN 1-85833-859-X

Printed and bound in Italy
Colour Film Reprographics by Image Setting, Brighton, England

CREDITS

For Paragon Publishing:
Project Coordinator: Dave Osborne
Art Director: Mark Kendrick
Copy Editor: Cliff Hope
Design: Peter Laws and Steven Gotobed
Picture Researcher: Sarah Moran

For Quadrillion:
Project Editor: Suzanne Evins
Production: Neil Randles, Ruth Arthur and Karen Staff

ALIEN ART

EXTRATERRESTRIAL EXPRESSIONS ON EARTH

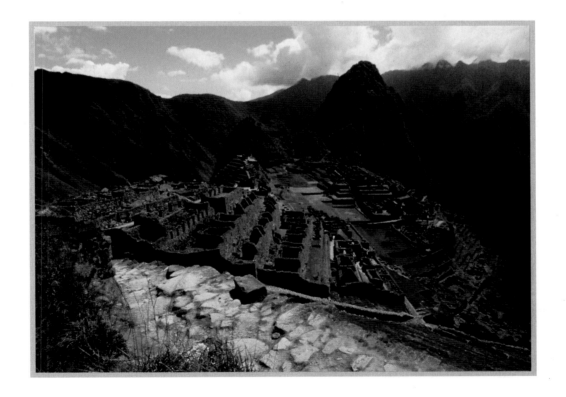

Sarah Moran

CLB

CONTENTS

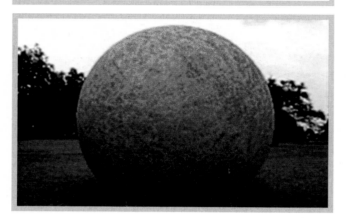

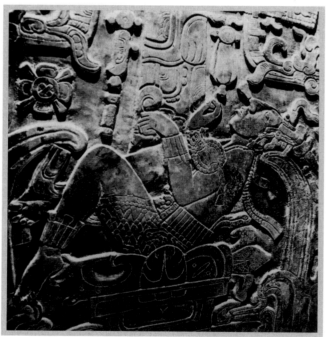

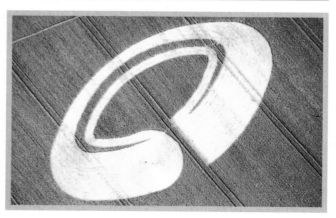

CHAPTER FOUR
ANCIENT MONUMENTS

CHAPTER FIVE
ALIEN ARCHITECTURE

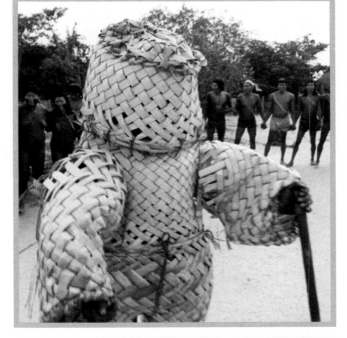

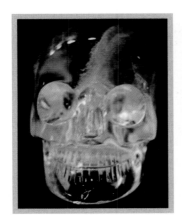

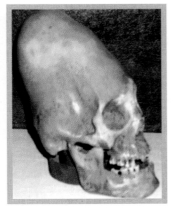

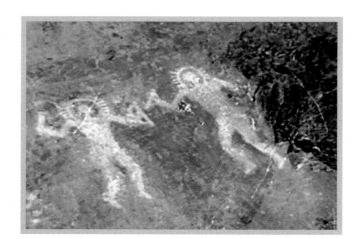

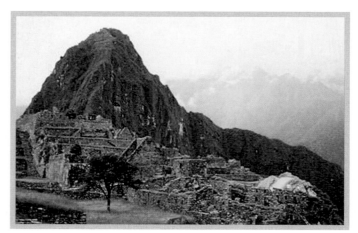

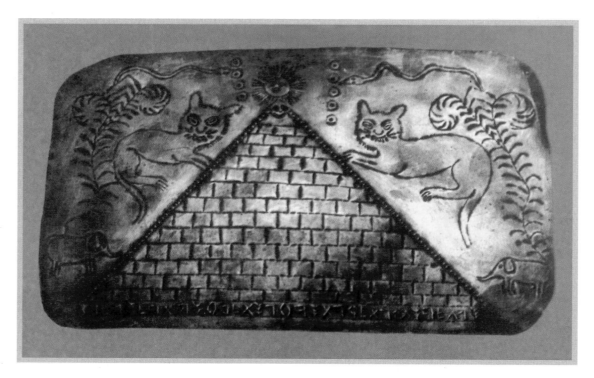

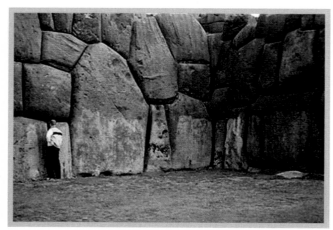

FOREWORD

Since the early 1970s, I have been trying to act as a sort of non-religious missionary spreading the idea that we have been visited by extraterrestrials in our past. My research has taken me all over the world. I have examined monuments, paintings, and artifacts as well as recording many local myths and legends which tell of powerful visitors from the stars.

I myself am convinced that our planet has been host to alien life-forms. More than that, I believe we were in part created by these genetic engineers from the sky. Whether this was 30,000 or 60,000 years ago I don't know. I don't even know where these benevolent beings came from, but I do know that they left vital clues to their existence behind them. There are inconsistencies in our past which must be re-examined. We need to know who created such enigmas as a battery that is thousands of years old and how did ancient people manage to cut solid granite with laser-like precision?

Many conventional scientists and historians have dismissed my books, or worse called them "dangerous," but I disagree. How can having an open mind be dangerous? What they do is cause ripples on the pond of accepted thinking and to some this is a real problem. When, and if, a scientist can explain our extraordinary ancient history to me satisfactorily then I will have to give up my quest. But more and more evidence is being uncovered, and surely now, when even NASA is putting money into researching life on other planets, it is time to push for some real answers.

As I witness all manner of strange "clues" on my travels, I do my best to describe and document their meaning. But very often it is the object itself that is so remarkable. For me the most convincing evidence is there before my eyes, simply seeing these remarkable feats of alien art is proof enough that historians have got it wrong. That is why I am delighted to be introducing *Alien Art: Extraterrestrial Expressions on Earth*. It brings together some of the most extraordinary pieces of architecture, carvings, and artifacts that cover our planet and gives you the sense of wonder that I myself have felt when I have come across them in real life.

The evidence that extraterrestrial intelligence has visited Earth is contained in these pages. When it is presented together in such a way, it is incredible that for so long we have got it wrong. It takes courage to open your mind to such a radical theory, but I honestly believe that we have no choice.

Erich von Däniken
February 1998

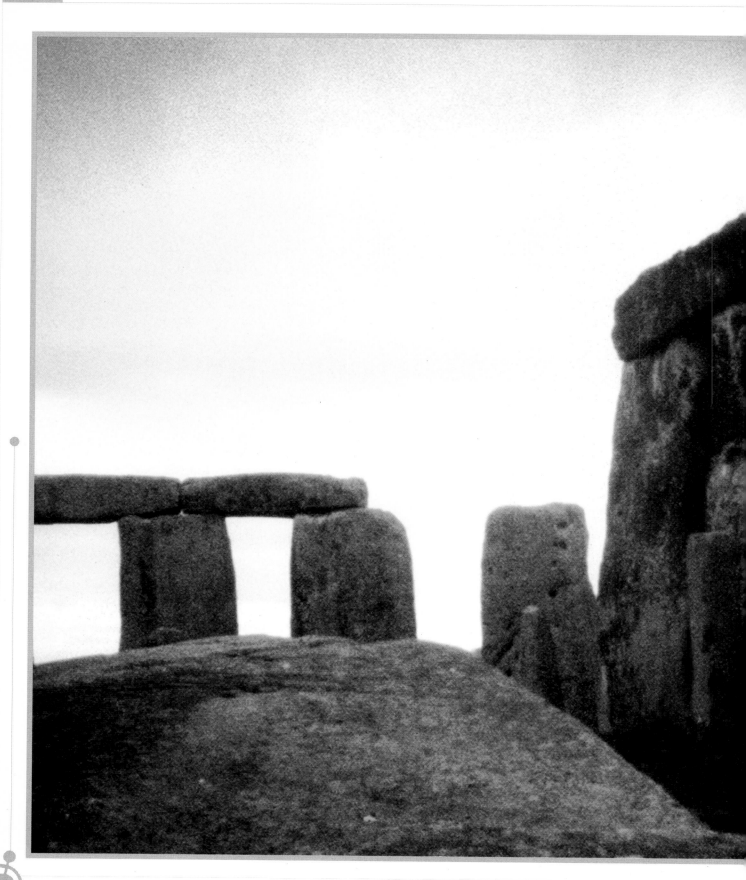

INTRODUCTION

There are many mysteries surrounding our planet, but none so vexing as mankind's hidden history. We are obsessed with questions about how we have reached this point in time and developed into the technologically advanced beings that we are today. There are so many puzzles which we are not clever enough to solve; we may have traveled to the moon and mastered such scientific developments as nuclear weapons and genetic engineering, but there is part of our past that we still cannot explain.

Evolutionists follow Charles Darwin's theory to the letter. They, and mainstream science, tell us that we are simply part of the planet's evolutionary process, changing and adapting in a "survival of the fittest" manner until we reach the point where we are best suited to live in our environment. This process, according to the accepted viewpoint, started around 1500 million years ago when the first cells formed from the soup of acids and proteins in the oceans. It took another 300 million years of evolution for organisms with more than one cell to evolve and a further 1050 million years before plants made it onto dry land.

Man, or *Homo sapiens*, is said to have evolved over 40 million years, initially being one branch off from an early form of ape. This "missing

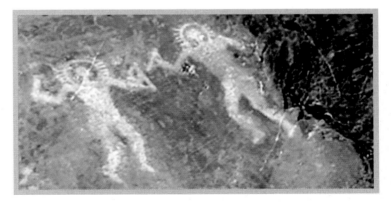

From the familar sight of Stonehenge (left) to the bizarre spacemen of Val Carmonica (above), extraordinary evidence of alien ancestors stands silently before us.

13

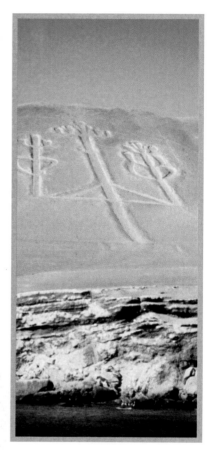

The Andes Candelabra, not just an elaborate hillside carving, but potentially a device to measure earthquakes.

link" between ourselves and the apes has never been discovered, but scientists still argue that as a species we underwent a slow transformation from ape to primitive man, to *Homo erectus* and then finally to the biologically and intellectually advanced mammal that we are today.

On the face of it this seems a reasonable theory, but increasingly there are anomalies which throw doubt on the very essence of human development, and ironically these doubts come from the very place where scientists draw their so-called "proof."

When Darwin wrote his *On the Origin of Species by Means of Natural Selection* in 1859, there was no evidence to support his new radical theory. Before that, the Creationists held the popular belief that God had created the world and each species had been created as they appear today. It was blasphemous to believe otherwise and besides, as religious scholars pointed out, there was no proof at all for such a preposterous theory. When the "proof" started emerging in the form of fossils and ancient monuments, scientists eagerly pieced the various fragments together and declared Darwin a genius. From then on, evolutionary theory has been accepted by most people and is generally taught in schools as fact.

This may be the accepted view, but then for centuries we believed space travel was impossible or even that the world was flat—and we were wrong. While there isn't yet enough evidence to totally destroy the evolutionary theory, there are real problems with man's own development, and these problems have come to light because the relatively small amount of evidence we have of our primitive forebears is now being re-examined, and some researchers believe we have indeed got it wrong.

When German writer Erich von Däniken wrote his first book *Chariots of the Gods* in 1968, it caused a storm. Von Däniken claims that all over our planet there are amazing examples of architecture and artifacts which simply defy our conventional understanding of our own development. Von Däniken's extensive research led him to the conclusion that man's evolutionary process has not been a natural one, but instead has been subjected to one or more major events which led to us becoming the superior species we are today. He believes that these "major events" were the direct result of extraterrestrial visitors who interfered in our genetic make-up.

Chariots of the Gods was laughed at by the majority of the scientific community who made a concerted effort to refute its claims, but it

also proved to be the catalyst for hundreds of other researchers to sit up and re-examine some of our accepted beliefs. Was it so much harder to believe that we were once visited by an alien race, than our accepted theory that it took man a mere 250,000 years to evolve from primitive, nonspeaking cave dwellers to the articulate, technically advanced city dwellers we are today?

The word "alien" provokes many images, mainly fictional and by and large aggressive. If there is extraterrestrial life on other planets then it is unlikely to resemble the "litttle green man" that has become synonymous with the word. Throughout this book I have used different terms to describe these shadowy figures from our past. It somehow makes it a little easier to comprehend when the sci-fi "alien" is dropped and instead we have "sky gods" or "star people" to deal with. This is how our ancestors referred to their ancient visitors, without the trappings of B-movie influences. The few records that our ancient ancestors left have done well to survive this long. In mankind's

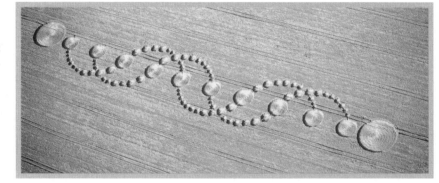

turbulent history, great libraries have been burnt, whole cities have been ransacked, and the graves of ancient kings and queens robbed of their treasures. These acts of vandalism destroyed important clues to our past which could help us piece together a lineage that at the moment doesn't quite fit. It is perhaps testament to man's creativity that some of the longest surviving "clues" are embodied in his works of art, decorating the landscape with a permanent reminder of who we are and where we came from.

Within our materialistic 20th-century context, many of the carvings, paintings, and buildings within these pages may look alien, in the sense of being totally unfamiliar. But they were never supposed to be interpreted with so much prejudice. Art is the simplest and most honest form of expression and all I ask is that the evidence before you is considered with an open mind. No-one really knows whether our ancestors' legends of giant eggs falling to the earth and space gods emerging to create humans in their image and bring civilization to the various tribes are just myths, as we have always rather arrogantly thought. Perhaps as we reach the millennium it is time to take a closer look at the messages from our past that are left behind?

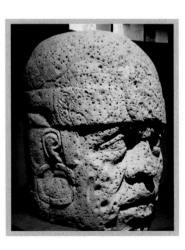

The ancient Olmec culture carved heads which often wore these puzzling protective helmets.

If the numerous ancient myths and legends are actually factual accounts of man's early history, then now is the time to accept the truth, for the alien art that covers our planet not only tells of our past, but speaks of our future—a future that may include the return of the star people. If that is truly going to happen then as a race we should be ready for them.

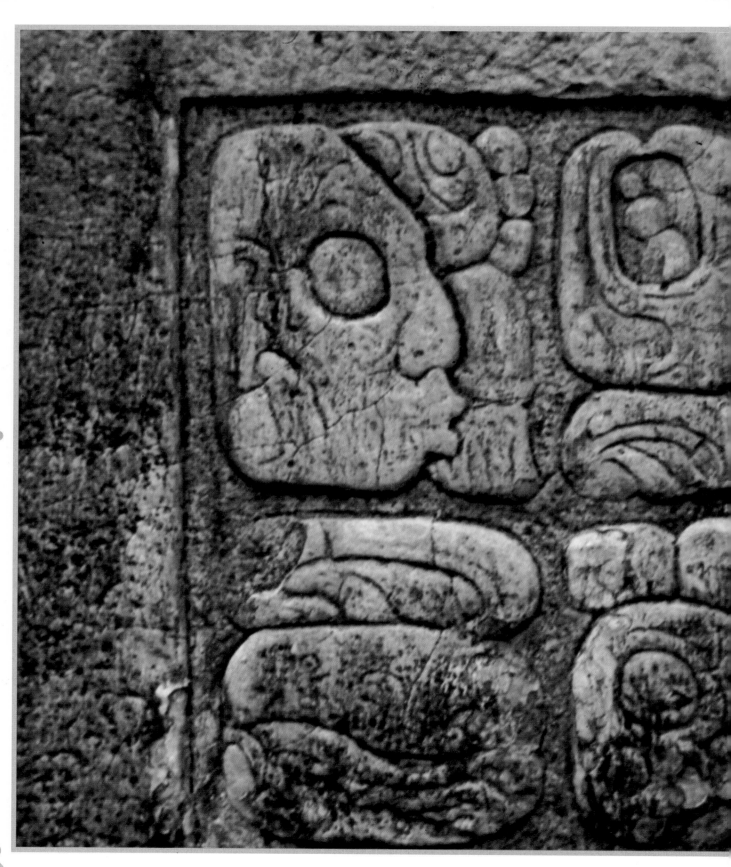

CHAPTER ONE
CARVINGS ON LAND AND STONE

The Earth's surface is scarred not only with millions of years' worth of natural wear and tear, but also with deliberate forms of ancient graffiti. Today we find little or no explanation for these often crude forms of artwork; they seem to have no other purpose than attracting tourists to marvel at their size and the guidebook definition of their meaning.

Carvings such as the Cerne Abbas Giant in England are infamous in their design and many people have speculated who made it and why, but satisfactory explanations are not quite so abundant. Other carvings, like those inside the Egyptian pyramids, are well documented, but despite our ability to understand hieroglyphics we still cannot always fathom their intended message.

More intriguing still are the giant carvings such as those in Nazca, which Westerners have only just rediscovered. No-one knows what the maze of straight lines, animals, spirals, and wedges signifies. Even the local people cannot explain their existence. The one thing that is certain is that the intricate patterns are meant to be viewed from above—but by whom?

Could there be a link between these giant creations, which their artists felt so strongly about that a mere painting on a wall would not suffice? Most of these carvings would have taken great planning, an intricate knowledge of geometry, and possibly access to technology such as our own.

If the artists were creating an everlasting image of a powerful force in their lives then we must begin to see further than the tourist attraction and study the history of these images.

As more and more evidence is assessed, the conventional dating of our history looks less certain. As our technology progresses to the point where we think there might once have been life on other planets, it is probably time to reassess our own past. We know so little about our ancient ancestors, constantly thinking of ourselves as far more "civilized," but it could be that these giant carvings are trying to tell us something. Not only did ancient legends speak of extraterrestrial gods who visited Earth, but they also promised that these gods would return. It could be time to consider whether our ancestors were hoping the sky gods would reappear, or were they very, very afraid?

Mayan glyphs: an undisciphered record of man's early history?

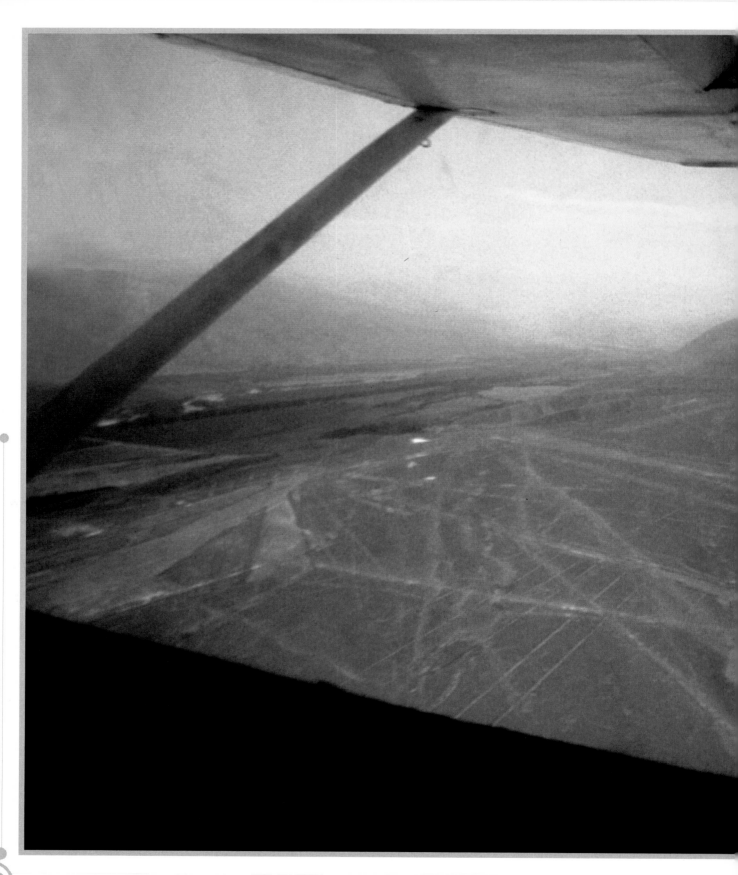

NAZCA LINES

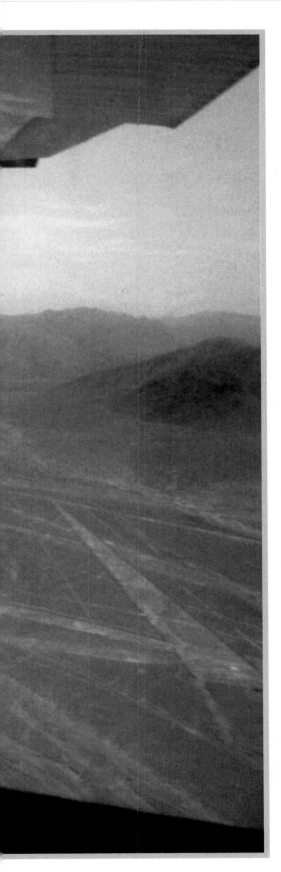

One of the most puzzling of Earth's mysteries is also one of the largest. The plains of Nazca in Peru feature an extraordinary array of etchings, which cover the 40-mile-long region of desert. Made by removing the top layer of stones, the mass of triangles, straight lines, wedges, and animals are thought to have been created between AD 400 and 900. The markings are often referred to as "Inca Roads," but this is misleading as they don't actually go anywhere.

It wasn't until an aerial expedition in 1939 that the true extent of the markings was discovered. Whereas on the surface of the plain the images are hardly discernible, from the air they form a giant canvas of artistic activity. The lines are perfectly straight (some go on for miles and even continue over mountaintops), the trapezoids have perfect angles, and the spirals are geometrically accurate.

The accepted view today, which is supported by the world's leading expert on the Nazca plains, Maria Reiche, is that the etchings form a huge and complex astrological chart meant to be viewed from above. Reiche, who has devoted her life to studying the drawings, believes the calendar was drawn for the benefit of the gods so that they would, for example, know when to change the seasons.

Other theories are more elaborate. Erich von Däniken is convinced the plain was an important landing site for extraterrestrial craft—the huge scars being pointers for spaceships trying to find their way back to Earth.

Only when viewed from above does the true scale of Nazca reveal itself.

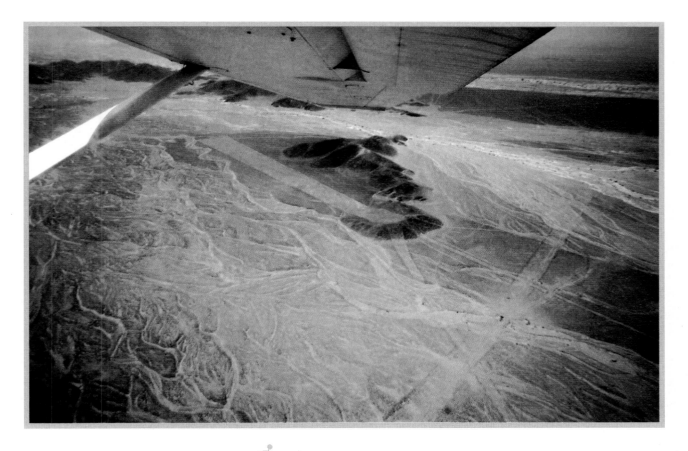

The complex arrangement of lines, triangles, and giant animals at Nazca remain one of the planet's greatest mysteries.

Whether the Nazca drawings are a calendar, roads, or ancient runways, what isn't in dispute is the fact that they must have been created to be viewed from above.

Among the many interweaving lines and wedges are extraordinarily detailed representations of wildlife. The most clearly defined of these are the monkey with its giant spiral tail, the 140-foot-long spider, the killer whale, and the giant birds. What is particularly noteworthy is that certain animals, such as the monkey, are not native to the area. So how did the artists know how to draw them?

To put the sheer enormity of these Earth drawings in perspective, the monkey is the size of a modern soccer field, while the largest of the 18 representations of birds measures 600 feet in length. Why did an ancient culture create such a complex easel of symbols? And who were they intended for?

Some researchers have likened the Nazca canvas to the records of dream states by Native American shamen, who traveled in a self-induced trance with the spirits of animals to visit the ancients (star gods) for wisdom. Could Nazca be a giant record of the ancients' interactions with their gods? Whatever their purpose—and that is likely to remain a mystery—they still lie in the red dust looking defiantly up at the sky, almost as if they are waiting for someone.

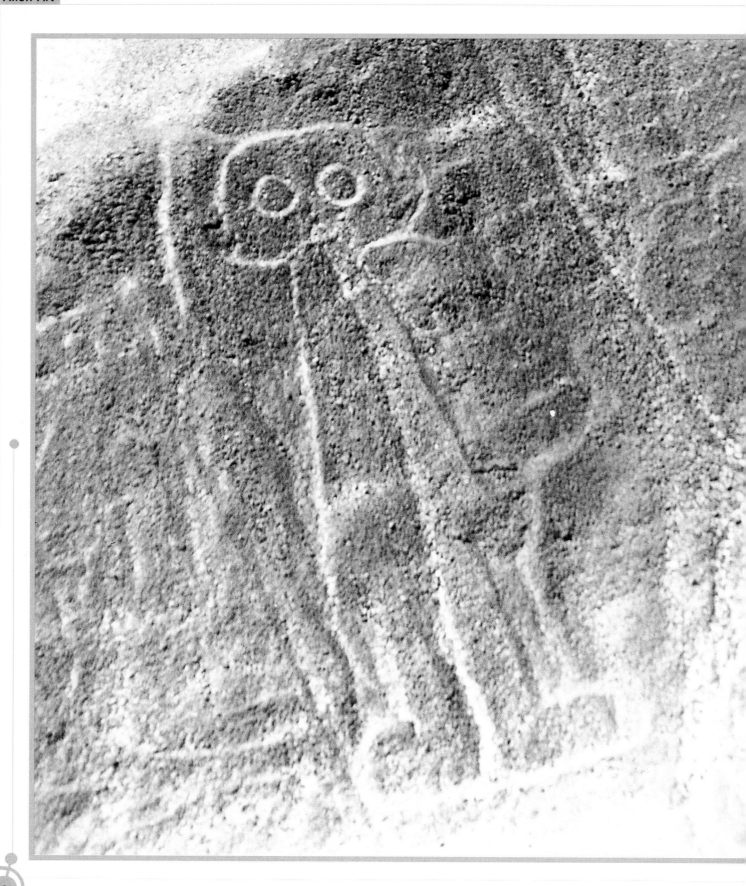

NAZCA ASTRONAUT

On the mountainsides that look down on the plains of Nazca, strange carvings oversee the ancient artists' canvas. Conventional researchers have said these figures are depictions of the artists themselves, but when one sees how lifelike the Nazca animals are, and then examines the very stylized figures on the mountainsides, this seems to be a misinterpretation.

Erich von Däniken has suggested that these figures, one of which is pictured opposite, represent the beings who landed their craft thousands of years ago on the plains. He maintains that the whole area, including the extraordinary Candelabra (see pages 30–31) has been carefully designed as a marker to guide the extraterrestrials back to Earth safely. He also maintains that the alien visitors have used the site more than once in our past.

This strange depiction of an unknown being even features antennae.

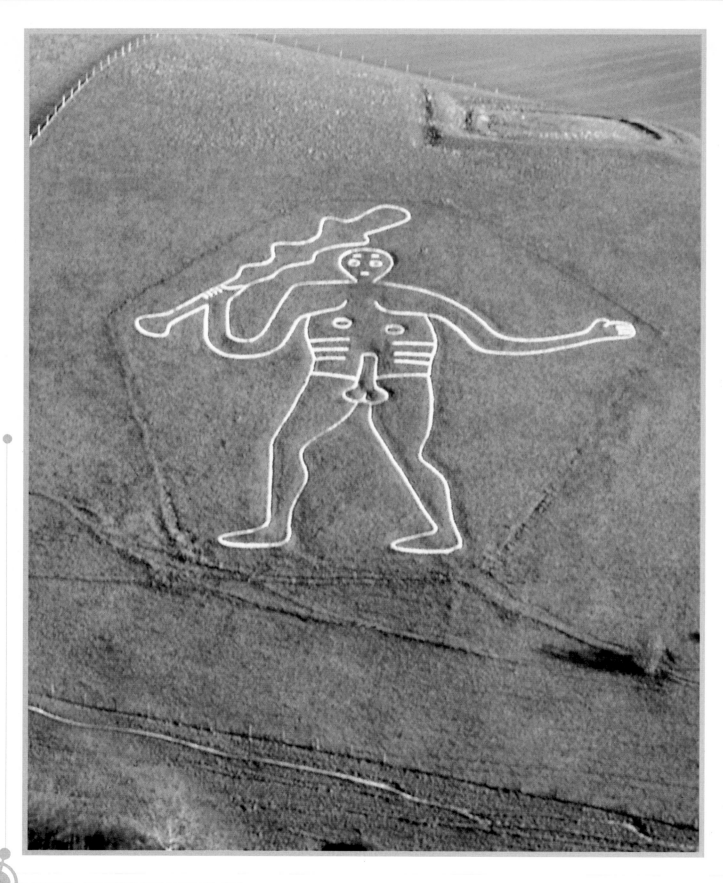

CERNE ABBAS GIANT

The reasoning that the Nazca artists deliberately created their works of art to be seen from above is also applied to other giant forms of artwork all over the world.

The Cerne Abbas Giant, thought to be created by prehistoric artists (see opposite) in Dorset, England, is an immense carving of a gigantic man-figure measuring almost 200 feet high. The giant's club is a threatening 120 feet long, but it is his other striking feature, the 30-foot-long erect penis for which he is most famous! Traditionally thought of as a fertility symbol because of his appendage, he has also been described as a form of scarecrow, created to terrify nearby tribes.

Again, archeologists are unsure who initiated the carving, but some researchers have suggested that more attention should be paid to the giant's eyes and head, which are not particularly human-like. Is the carving a representation of the giant visitors who brought civilization to ancient England, or could it even be an image of an extremely fertile warrior threatening the invaders from the stars to stay away?

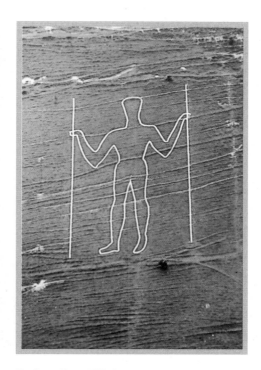

The Long Man of Wilmington on the East Sussex Downs in England has a very similar simplistic outline to that of the Cerne Abbas Giant, but its features are missing and it holds two perfectly vertical rods in its hands. There is no reason to assume this carving is a fertility symbol, but again, experts are unable to come up with a more satisfactory explanation.

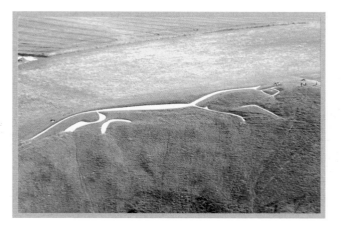

The Uffington Horse, in Oxfordshire, England is thought to represent a dragon or flying horse, especially because of its close proximity to the nearby Dragon Hill. No-one knows its original purpose, but many have suggested its stylized appearance is best viewed from above.

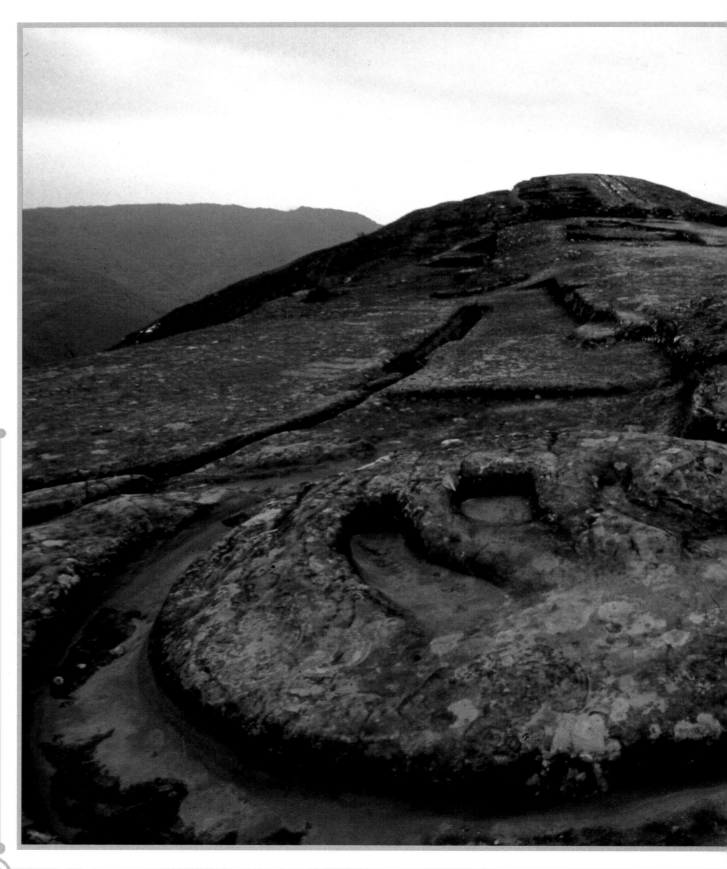

SAMAIPATA

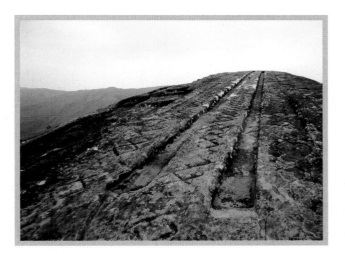

The traditional historical view is that a farming race of people called the Aymaras established an early pre-Inca culture in the area in about AD 900, but the carvings at Samaipata have no farming use and are thought to be from a much earlier period.

Samaipata in Bolivia is 6500 feet above sea level and is one of the most important archeological sites in the country. Its mountaintop ruins are a fine example of Inca building work, but as with most of these beautiful sites, it contains many mysteries and clues to our past. The hard rock ground has been inscribed with various designs, just like at Nazca, but not of the same size or complexity. No-one knows who commissioned these works of art, but many, as in the picture opposite, are geometric shapes and patterns.

Suggestions that it was a landing site for UFOs have been largely dismissed because of the inaccessibility of the area, although Samaipata does mean "a place to rest in the mountains" in the local dialect Quechua.

BIMINI ROAD

An underwater view of what has become known as the Bimini Road. The respected medium Edgar Cayce predicted Atlantis would be discovered in 1969, and he said it would be found near Bimini! Archeological investigations at the site have so far been sketchy, but if most of the construction is buried in the sea bed, it must surely be worth the effort to uncover and prove what is one of mankind's longest surviving myths—the legend of Atlantis.

The search for Atlantis, which some Ancient Astronaut theorists believe was the place where the extraterrestrials initially landed and set up the first civilization, has captured man's imagination through the ages. In 1968 two archeologists, Manson Valentine and Dimitri Rebikoff, were diving in the Bahamas when they discovered what Erich von Däniken describes in *The Gold of the Gods* as "submarine settlements with walls from 230 to 812 feet long which lay more than 20 feet under water, extended over an area of 38 square miles! There were parallel walls more than 2000 feet long. The weight of a single 16-feet-long stone was more than 25 tons."

Again, according to von Däniken, scholars from the University of Miami, USA have dated the strange underwater settlement of Bimini to between 7000 and 10,000 BC. If we put this in the conventional chronological chart, it even predates the Great Pyramid.

The only clue to the underwater "city" is a giant carving on the hillside at Bimini. It is thought to be a whale or giant fish. Further than that, its significance is lost in modern times.

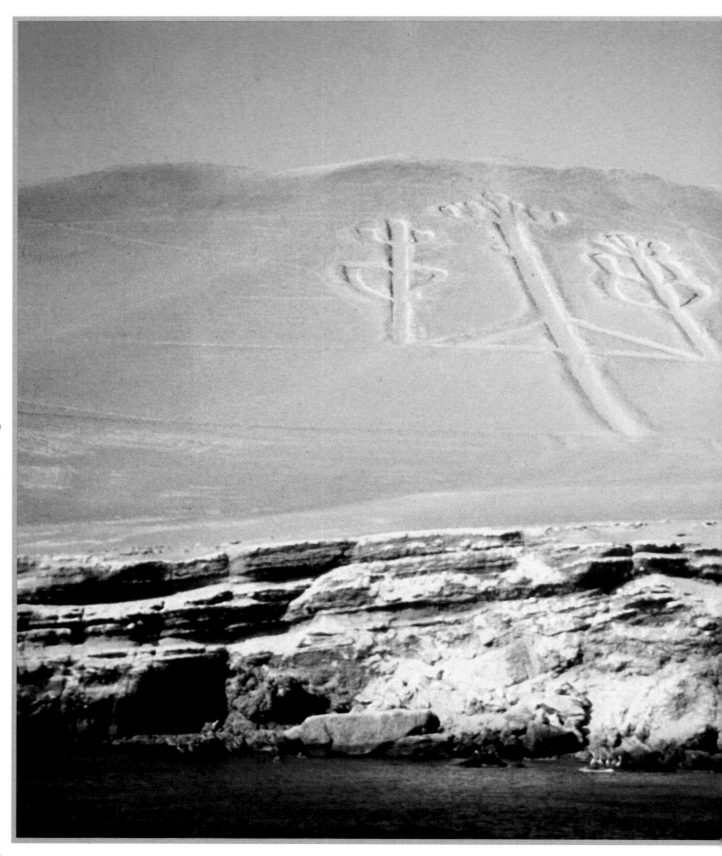

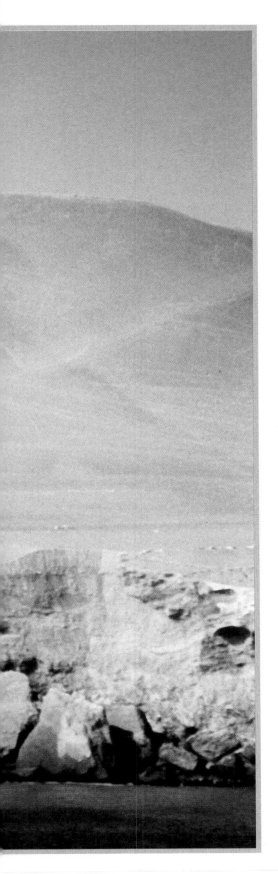

ANDES CANDELABRA

When the Spanish conquistadors first saw the 800-foot-high carving on the edge of the Bay of Pisco in Peru in the 16th century, they allegedly thought it was a sign from their Christian God that their mission was blessed, but the carving, which is visible 12 miles out to sea, had a much more intricate purpose. Long ropes were discovered in the center prong of the trident, which seems to suggest the Candelabra was used as a pendulum or measuring device of some kind. It doesn't appear to have a direct relationship with the sun, which has led to further speculations as to its use. Researcher Garcia Beltran suggested, "With counterweights, graduated scales and ropes that ran through pulleys, the system constituted a gigantic seismograph capable of precisely measuring earthquake vibrations not only in Peru, but all over the globe." Where did the ancient designers and mathematicians learn to build a seismograph? Surely that level of knowledge could only come from a higher, more advanced civilization?

Who created the giant Andes Candelabra? It was certainly used by the Incas, but is thought to be much older, although exactly how old is just guesswork. Its position in the desert of Paracas in Peru has led some archeologists to suggest its significance could be linked to the Nazca plains. Is it an aeronautical marker pointing to the landing site at Nazca?

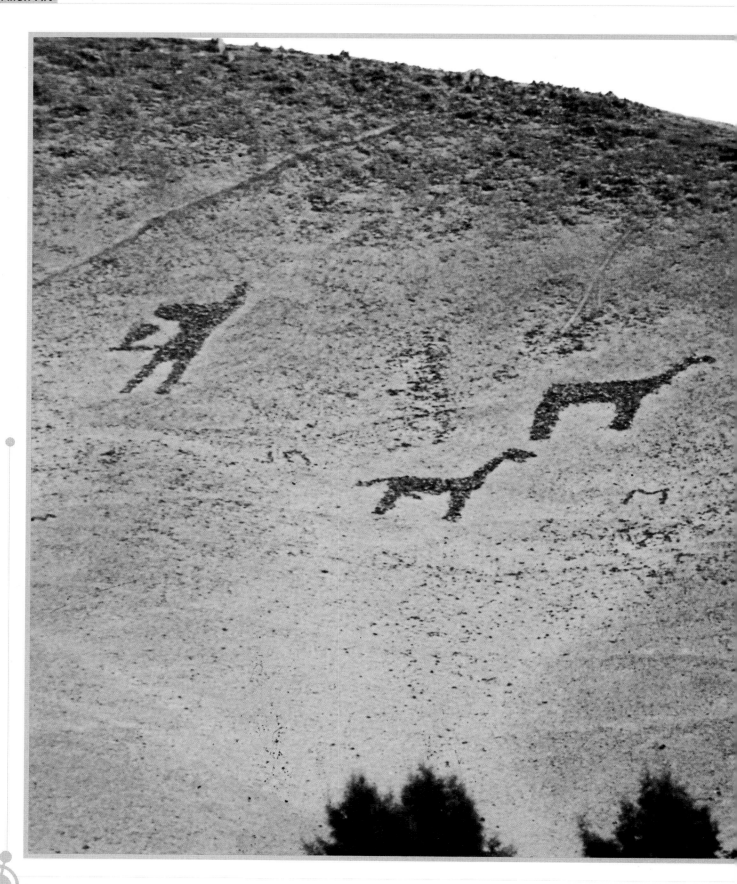

ARICA DESERT DRAWINGS

Arica in Chile has been prone to wars and has therefore been a difficult area for archeologists to study, but it is thought that a copper-using culture lived in the region at least 2000 years ago. Some of the oldest mummies in the world have been found at Arica, preserved in the desert sand. They are now on display at the Archeological Museum in Arica with a tentative dating of being 10,000 years old!

Arica also boasts an extraordinary group of giant petrogylyphs which are strange mixtures of animals with vaguely man-like features. The drawings are so large that they must have had a purpose, rather than being purely decorative. The strange forms are obviously trying to convey a message of some kind to someone.

Following Erich von Däniken's line of thinking, should we consider the possibility that they tell of genetic mutations which were engineered by the giant sky gods? If the extraterrestrials did reconstruct our DNA to produce a "super-human" version of *Homo erectus*, did they also tamper with the DNA of other animals? With the recent success of animal cloning and the identification of DNA, does the Ancient Astronaut theory have more credence? Would ancient man have been given the power to raise genetically superior livestock, or did they simply watch their gods at work and marvel at their incredible powers?

The amazing carvings of the Arica region have puzzled historians for centuries. Their purpose, meaning, and even their creators, remain a mystery.

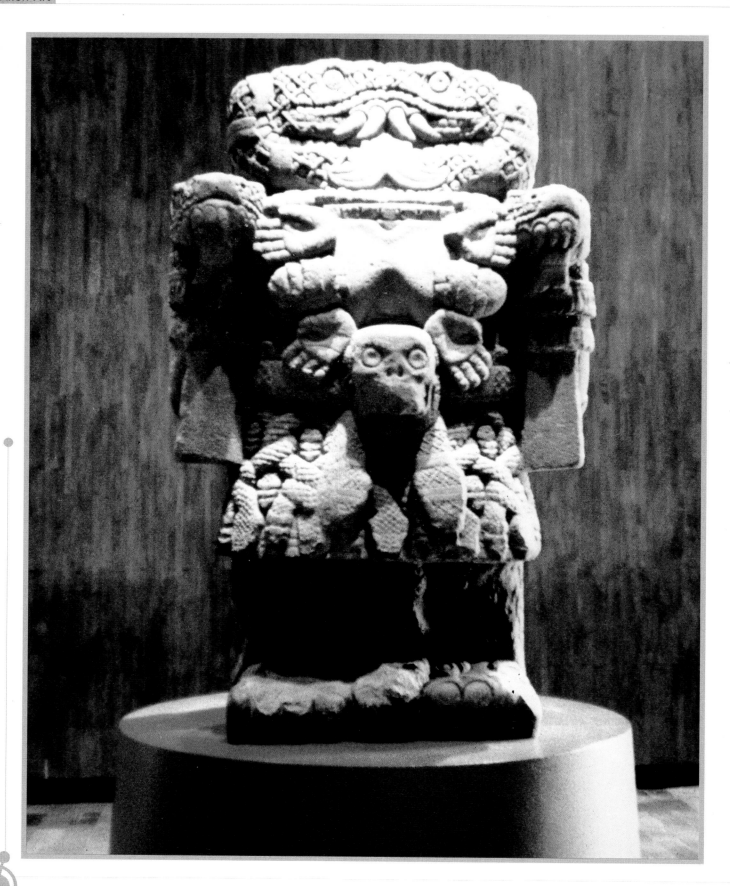

MAYAN GLYPHS

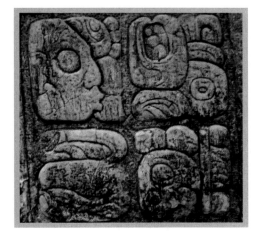

Mayan glyphs at Palenque, Mexico. Researchers believe each pictogram conveys a statement or feeling rather than a specific word or letter. Although most carvings still have to be deciphered, the recurring themes of astrology, astronomy, and mathematics have been initially identified.

Throughout the remnants of the Mayan civilization are examples of a largely undeciphered language which appears to have been the communication tool used mainly for the recording of important myths and legends. The external walls of exquisite temples, such as those at Palenque, are covered with these mysterious representations which have an uncanny resemblance to Egyptian hieroglyphics.

Vital clues about our ancient ancestors' history could be hidden within these elaborate carvings. It is already known that the Mayans had an extraordinarily detailed knowledge of the star system and because of this they developed a calendar system which was even more accurate than ours today. They were also obsessed with recording dates, mathematical problems, and their past.

They had independently developed a number system so sophisticated that it rivals our own today, and all this was recorded in great detail to safeguard their knowledge for years to come.

There are so many enigmas surrounding the Mayan civilization, all of which may be solved if meticulous research were to be carried out on the numerous surviving examples of these exquisite glyphs. Why did their calendar begin in the year 3113 BC? What was so special about that date? Why did they look to the future in cycles of 7200 days? Why did Mayan aristocrats bind the heads of their children to stretch their skulls? Who were the revered feathered gods who came down from the sky? And why did such a sophisticated culture disappear so suddenly?

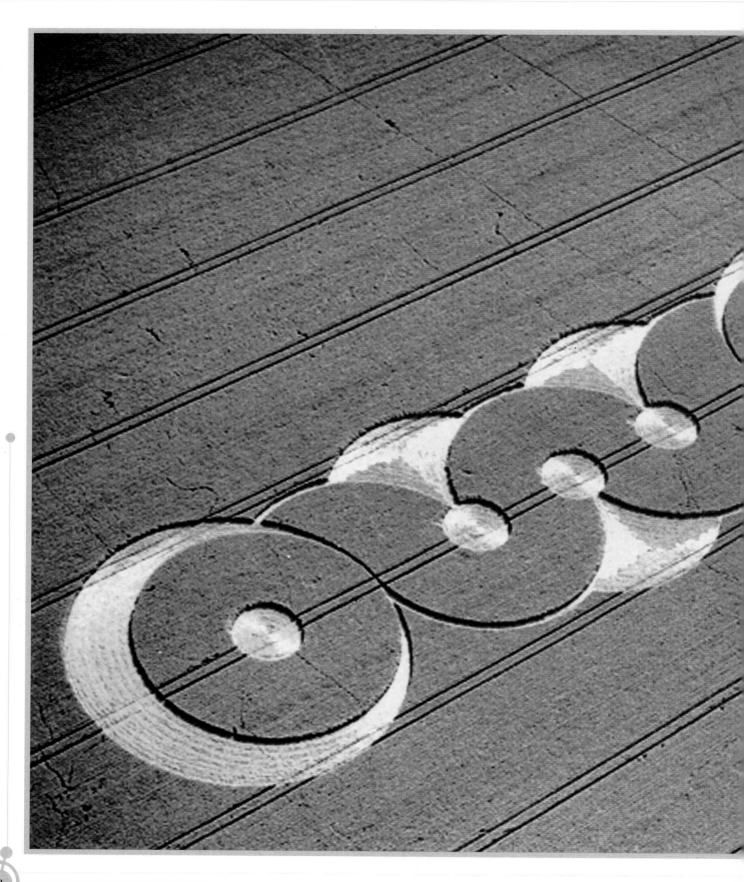

CHAPTER TWO
EARTHLY ILLUSTRATIONS

For centuries Earth has been used as a gigantic canvas for spectacular illustrations by anonymous artists, and these have provoked argument and debate within the confines of conventional science and history. Are these expressions of an individual or a collective, and are they there to inform, or could they be a sinister reminder of our past?

The earliest known illustrations have been found in prehistoric cave dwellings. Whilst most of these can be explained as man's early attempts to document his everyday life, some are strange, seemingly out-of-place pictures that are only just beginning to make sense. Many ufologists have interpreted paintings such as those at Val Carmonica in Italy—which depict strange white-clad figures with glowing sealed helmets—as historical recordings of alien visitations.

It has been traditional to interpret ancient artforms that depict anything out of the ordinary as fanciful depictions of myths and legends. The Anasazi Indian petroglyphs, for example, which depict the "star people" who, word-of-mouth tales say, came down from the heavens and brought many wonderful gifts to mankind, have been interpreted exactly in this way. But it seems rather arrogant and small-minded to approach ancient history constantly labeling its cultures as "primitive." If mainstream scientists, historians, and archeologists shook off the confines of our accepted (and in parts sketchy) chronology, and started analyzing the countless depictions of star people, sky gods, extraterrestrial visitors for what they really are, then perhaps our understanding and knowledge would be greatly improved.

Other earthly illustrations have not been quite so subtle or difficult to discover. In more recent times crop circles, the most spectacular yet most short-lived of all earthly illustrations, have provoked much debate. In 1686 Robert Plot, Professor of Chemistry at Oxford University, believed rutting deer or rampant cattle the most probable cause, although he didn't rule out fairies, admitting that "they may indeed occasion such circles." In contrast Professor Yoshihiko Ohsuki from Toyko's Waseda University conducted various experiments involving plasma fireballs, and deduced that elastic plasma or strong forms of ionized air could be the cause. Other researchers, including authors Robert Bauval, Graham Hancock, and John West, have popularized links between crop art and the creations of the ancient Egyptians, concerning the geometry and mathematics involved.

One of the more elaborate crop circles to have appeared in Wiltshire, England, in 1995.

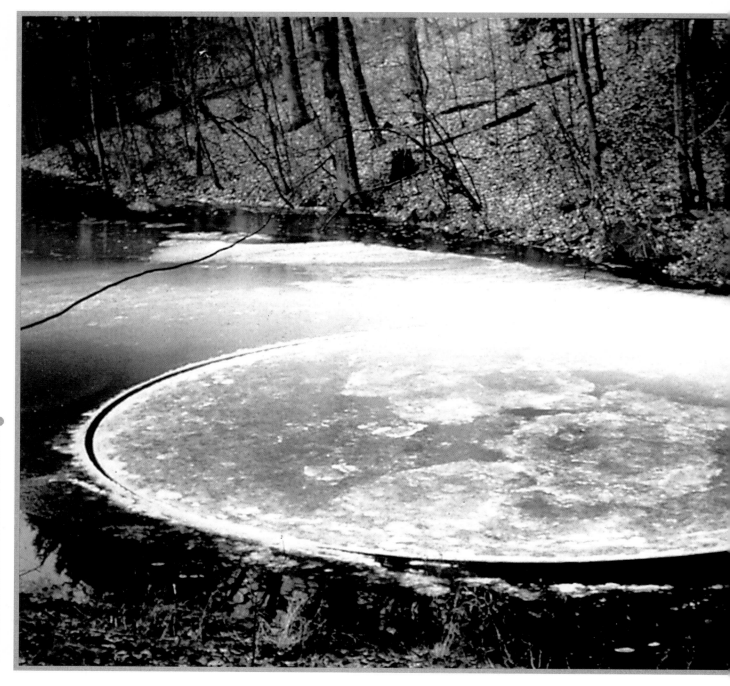

This extraordinary ice ring was discovered on Cranberry Creek, Tannersville, Pennsylvania, USA on January 27, 1993. When measured it proved to be 28 feet in diameter!

ICE RINGS

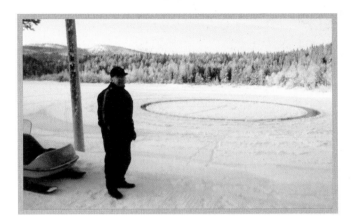

Ice rings, which some say are caused in the same way as crop circles by extraterrestrial artists who are trying to communicate with Earth, are a rare phenomenon. While conventional science maintains they occur naturally because of the flow of the water under the ice, it is still perplexing how such a perfect circle can just appear. And they do have an uncanny resemblance to simple crop circles, like those found in Japan and Canada.

A Swedish ice ring discovered by Gösta Nilsson in January 1987.

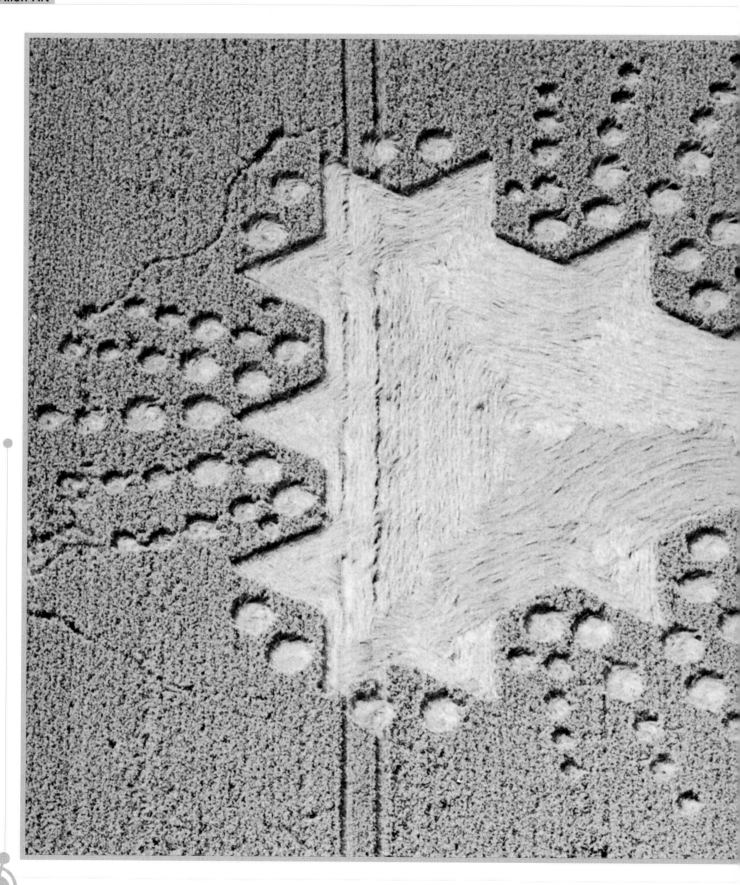

CROP CIRCLES

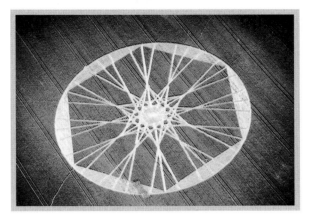

Clay Hill, Warminster, Wiltshire, England. This intricate geometric design appeared overnight in July 1997. No-one has claimed responsibility for this crop circle.

Some of the most spectacular earthly illustrations are also the most short-lived. Crop circles, contrary to popular belief, are not a modern phenomenon, but have been reported throughout the ages. Native Americans recorded coming across circles on the plains which they attributed to the star people, and this connection to alien visitors has stayed with us.

Although some recent circles have been proved as fakes, many others still defy explanation. Most "genuine" circles have appeared near so-called energy or "ley" lines, the most spectacular ones appearing in the vicinity of Stonehenge, in Wiltshire, England.

In recent years, crop-watchers have speculated that messages may be hidden in the circles, particularly those that seem to resemble DNA strands. Perhaps as our knowledge of human biology advances, the brief messages from above will make sense.

This particular crop circle appeared at Hackpen Hill, Wiltshire, England on August 18, 1997. It is interesting to note the many smaller circles radiating outwards from the central design, itself based on a mathematical "fractal" pattern.

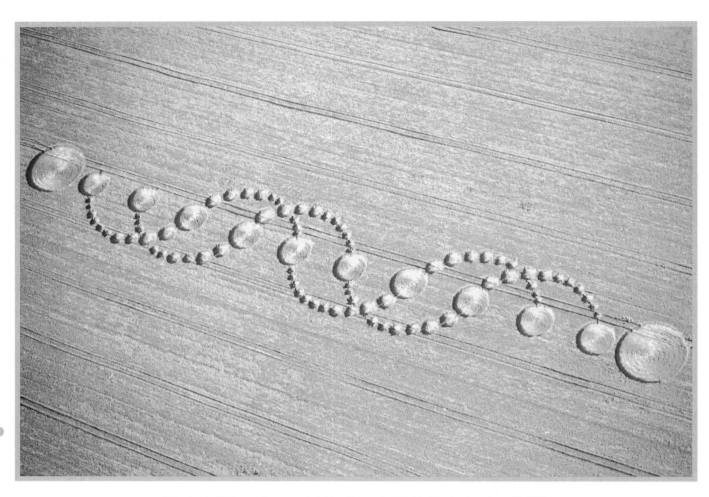

This classic DNA strand appeared at Alton Barnes in Wiltshire, England on June 17, 1996.

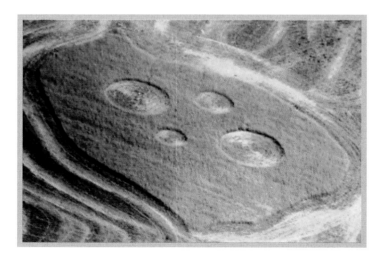

Crop circles at Warner, Alberta, Canada in September 1991. There were no visible signs of human entry, although the wheat was very dry and easily damaged.

An interesting example of crop art formed near Stratford-upon-Avon, England, on July 15, 1997. Its message is open to interpretation.

Crop-watchers have reported higher than usual energy levels around the sites where circles have appeared and some have allegedly seen UFOs. The general public's skeptical attitude to this amazing phenomenon was in some way vindicated by two Englishmen, Doug Bower and Dave Chorley, who in 1991 admitted to having faked some circles and even went so far as to show a national newspaper how it was done.

Recently, however, a student accidentally videoed a crop formation in Wiltshire, England. The footage shows an elaborate circle being formed by two very bright lights in the sky revolving in expanding orbits. When the design is finished, the lights speed off and disappear.

We may have the skills needed to replicate this bizarre phenomenon, but it seems more logical to put our energies into deciphering their messages. If they are a form of extraterrestrial communication in a language that our ancestors understood, but is now lost to us, then only further archeological study will enlighten modern man.

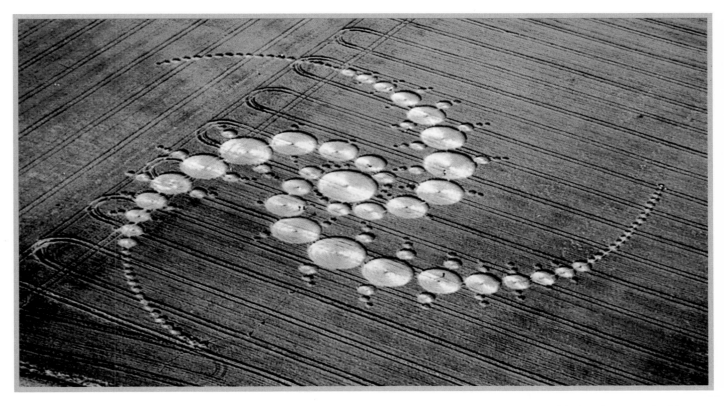

Avebury, in Wiltshire, England, July 29, 1996. This amazing set of circles appeared near the mystical standing stones of Avebury (see pages 94–95).

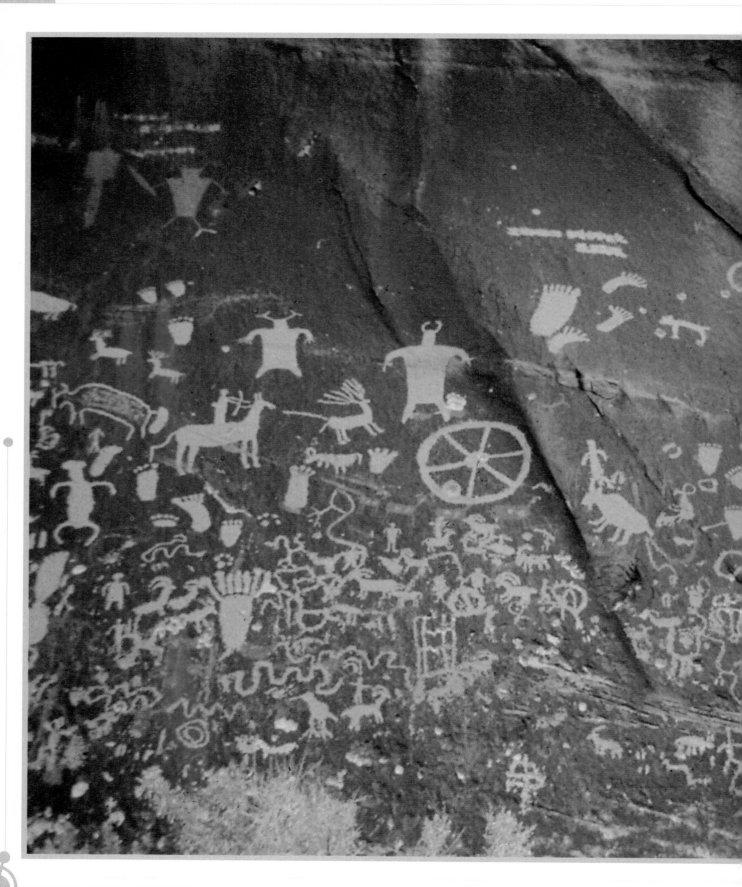

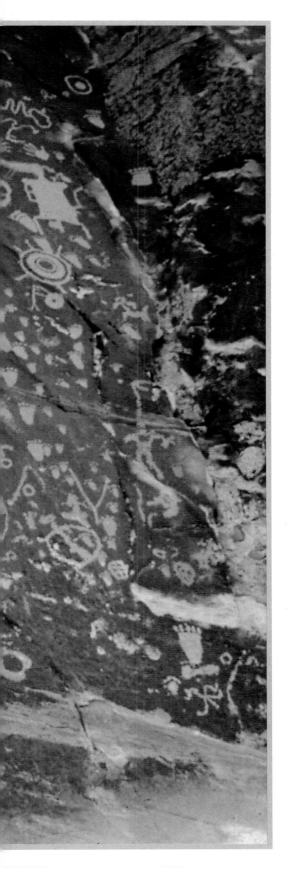

ANASAZI INDIAN PETROGLYPHS

The Anasazi, one of the earliest recognized tribes of the northwest Native American Indians, passed down many legends associated with visitors from the star people through their generations. The traditional view of early occupation by Native Americans is that travelers arrived from Asia and archeologists have relied on the very little evidence they have found to back this up, ignoring the ancient and detailed story records of the peoples themselves.

Petroglyphs, such as those found in Utah, are the pictorial equivalent of the ancient "myths." The Anasazi drawings portray the importance of the astrological medicine wheel as well as various larger than life beings descending from the sky.

The star people feature in many Native American stories. They dwell in the Star Country in the clouds and control everything on Earth. Occasionally mortals visit the Star Country; they are usually young braves who are drawn to young female star people. Once in the clouds they are shown their own world through the eyes of the gods.

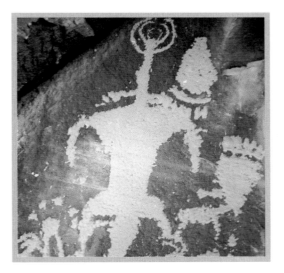

This giant being with strange "antennae" on its head is thought to be a stylized representation of a god from the sky.

The "newspaper rock" in Canyonlands National Park, Utah, USA, is an incredibly well-preserved example of Anasazi petroglyphs dating from around AD 1200. The symbols depict various aspects of Anasazi tradition and could hold vital clues about the visitors known as the star gods.

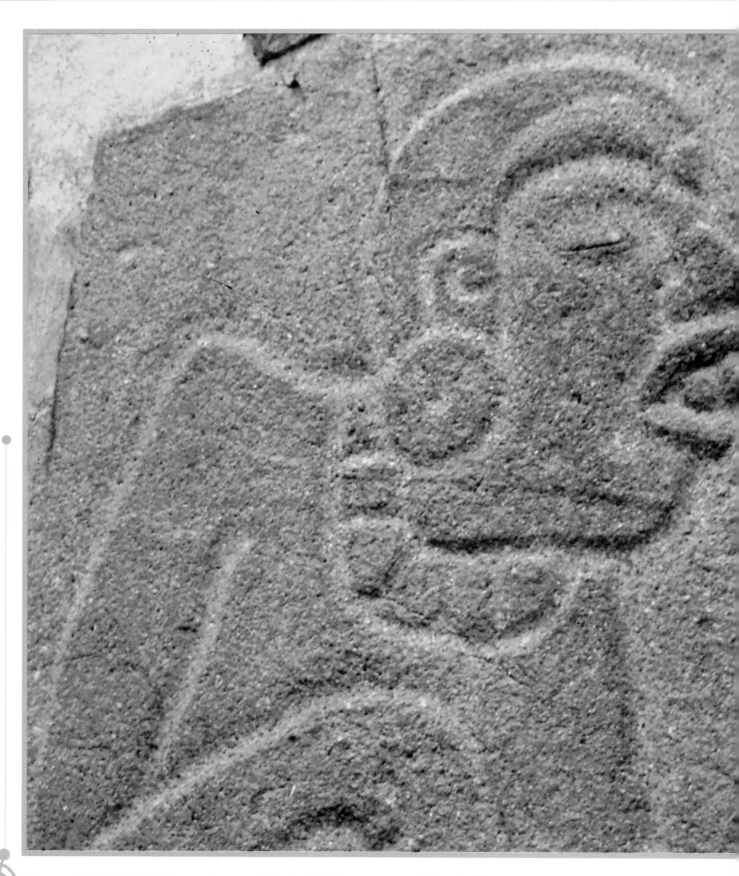

DANZANTES GALLERY

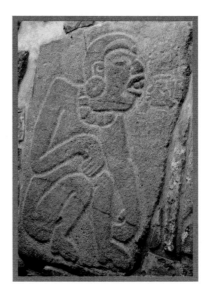

Erich von Däniken has spent over 30 years cataloging specific carvings and artifacts, such as these, which he says are not records of superstitious myths, but records of fact. Are we too arrogant to assume that our ancestors couldn't possibly record historical data accurately?

The Danzantes Gallery in Oaxaca, Mexico features a whole wall of carvings which have become known as "dancers," but their general appearance bears a marked resemblance to the Olmec heads with their space helmets and other stylized versions of the sky gods (see pages 66–67). It is thought that the artists of these strange dancers worshiped the Jaguar Being, just like the Olmecs. The Jaguar Being was the offspring of a powerful woman who mated with a jaguar. The carvings are thought to date from 1300 BC.

Ancient Astronaut theorists argue that these carvings should not be considered as the crude work of primitive artists, but should be judged in light of new evidence emerging about the scientific processes our ancestors possessed. Perhaps the drawings are not that crude—maybe they are merely representations of beings who didn't look quite like ourselves?

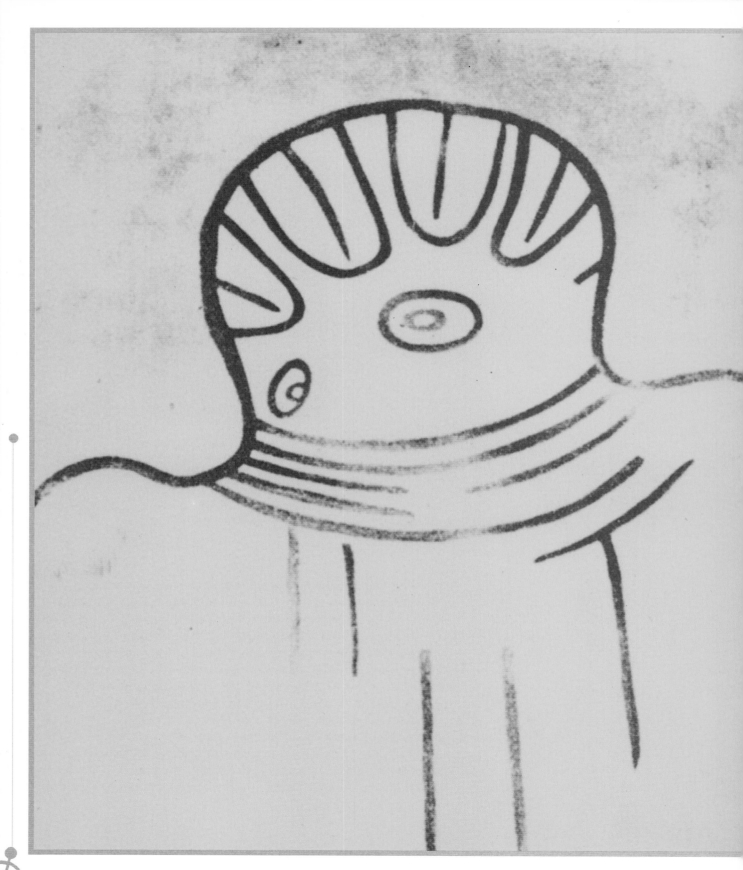

TASSILI PAINTINGS

The Tassili sky god image has often been presented next to pictures of the suits our modern astronauts wear, to show the marked and uncanny similarity.

The Tassili paintings in the Sahara desert are remarkable for their depiction of giant men wearing what appear to be spacesuits with joined headgear. The designs, thought to date from 6000 BC, have been linked to local legends which tell of gods arriving from the stars in giant eggs. A copy of one of the spacemen paintings, shown opposite, reveals how the helmet is tightly fastened to the suit. The actual painting is nearly 19 feet high, which suggests whatever the unknown artists were trying to portray was not insignificant.

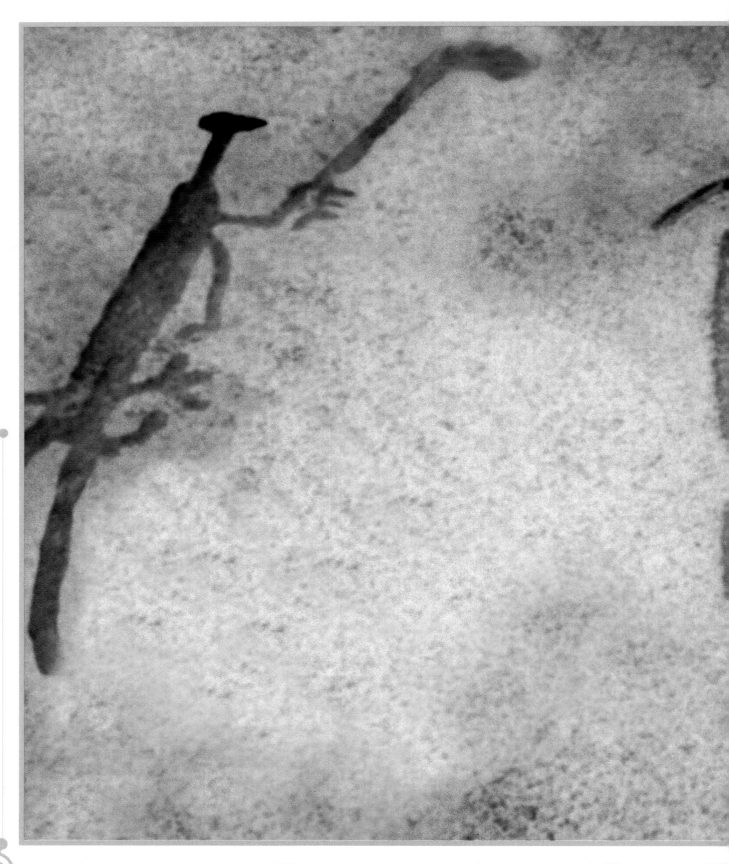

VAL CARMONICA SPACEMEN

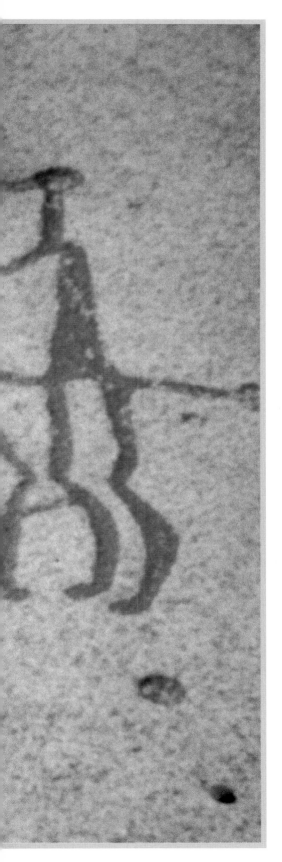

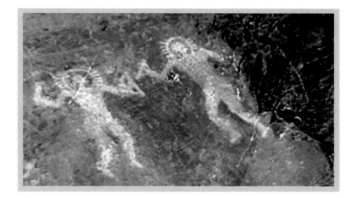

This image from Val Carmonica clearly shows two figures with glowing sealed helmets or halos of some kind, and while it would be impossible to categorize them as definitely being spacemen, no other satisfactory explanation has been found.

Erich von Däniken believes he has identified about "20,000 prehistoric paintings, including numerous radiating circles and 'gods' with helmets" in the Val Carmonica region of Italy. The radiating circles are allegedly significant because "all spheres and circles—whether in creation myths, prehistoric drawings, or later reliefs and paintings—represent 'god' or the 'god head'." He also says the majority of the spacemen paintings display bulky suits and either helmets or antennae. Whether we can suspend our disbelief long enough to accept the idea that all the Val Carmonica paintings are representations of space gods is down to the individual, but it has to be said there are some remarkable images which defy all conventional explanation.

A similar Bronze Age rock carving from Bohuslan in Sweden is thought to show a marriage ceremony with a sky god officiating. Although close in form, the sky god is much larger and appears to be overseeing what could be a physical union.

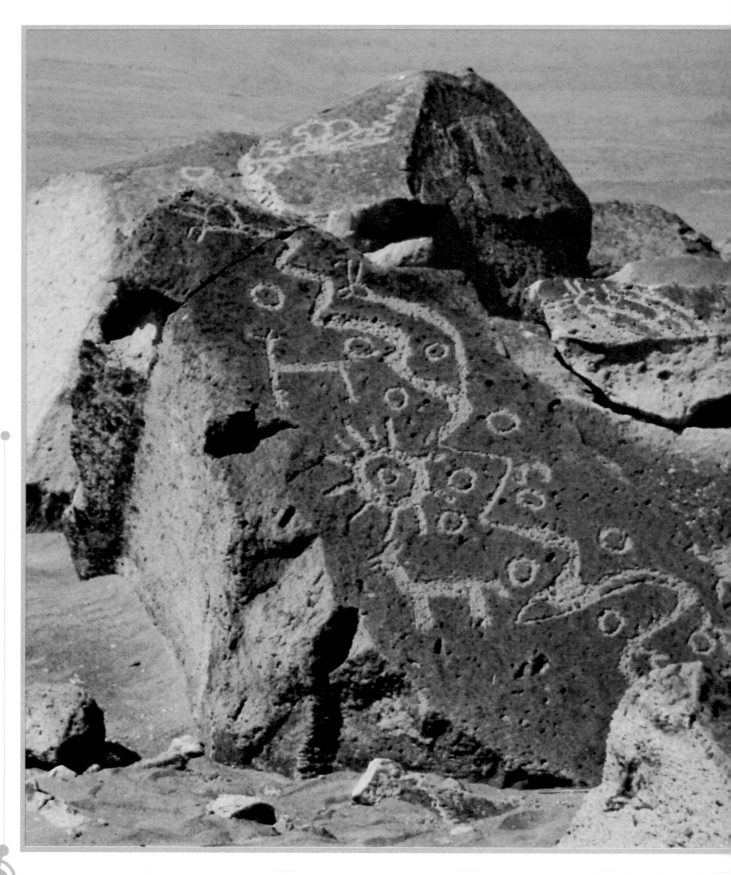

TORO MUERTE PETROGLYPHS

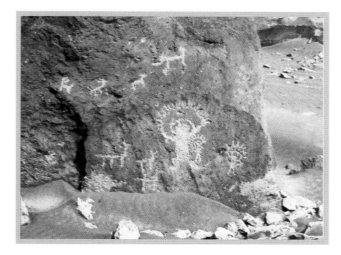

Another of the several thousand stones with ancient drawings in the desert of Toro Muerte in Peru. The figure with a "halo" is thought to represent a spaceman, or sky god.

Ancient petroglyphs, drawn by an unknown culture, have been found in the Toro Muerte desert near Arequipa in Peru. The group depicted opposite could well be an astronomical drawing of the Milky Way. Intricate knowledge of star systems has been found to be central to many ancient cultures, although why they needed such accurate astronomical information is still a mystery.

One of the most extraordinary stories recounting links with the stars is of the African Dogon tribe who still exist today. In his book *The Sirius Mystery*, Robert Temple followed up earlier investigations by two French researchers who had suggested the tribe had detailed knowledge of the Sirius star system and had been worshiping Sirius B as the place where their gods came from, for as long as they could remember. What is remarkable is that Sirius B isn't visible without a telescope and was unknown to Western man until recent times. Temple's convincing work documents the detailed knowledge of the workings of our solar system that the Dogon people have possessed and treated as fact for centuries.

Most ancient civilizations who believed in extraterrestrial gods or visitors—call them what you will—identified a specific star or planet in the solar system which was the god's home. The petroglyph on this particular rock is thought to be a representation of the Milky Way.

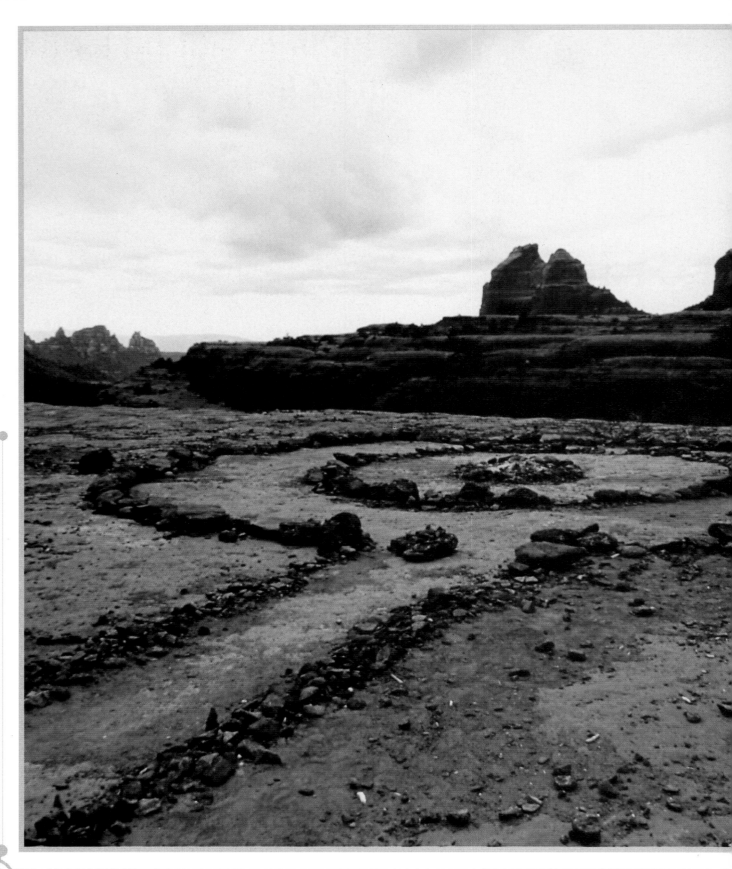

SEDONA MEDICINE WHEEL

Although the medicine wheel is a well-known Native American symbol, some of the older, larger wheels that were constructed on the ground may have more significance than they have previously been given credit for. They are thought to have been the North American equivalent of Stonehenge, using the sunrise and sunset at the summer solstice to mark out an intricate calendar. Is it possible that this advanced knowledge of the solar system came from the star people, the extraterrestrial visitors who are remembered in so many Native American legends?

In the legend of the Star Maiden, which is an Algonquian tribal story and typical of encounters with the star people, Algon, a hunter, wins the daughter of a star god for his wife. He initially discovers a circle worn in a field that has no signs of footprints. It turns out to have been created by a group of female star people who visited the Earth. The ancient myth echoes modern reports linking UFO and alien sightings with the creation of crop circles.

The Big Medicine Wheel near Sedona, Arizona, USA. Is it possible that it was more than just a calendar? Its size and positioning make it extremely visible from the air—could it have been a guiding beacon to help the star people's ancestors find their way back?

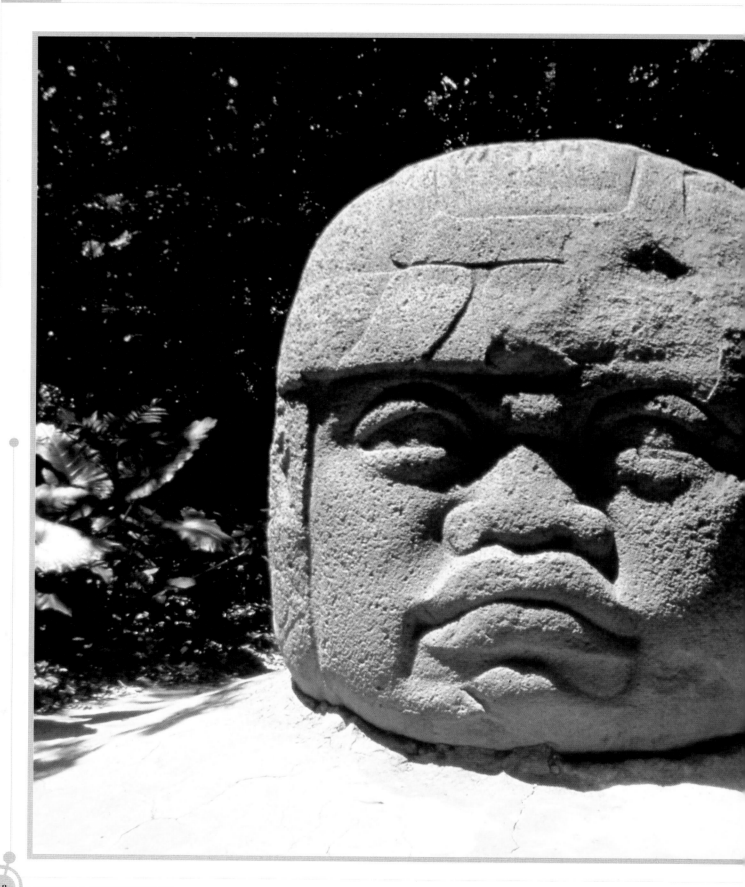

CHAPTER THREE
SCULPTURE AND ARTIFACTS

Tragically, our ancient history has all too often been plundered and desecrated by modern man who is too concerned with fame and fortune. Lying within the Egyptian pyramids, Mayan temples, and other ancient architecture are promises of treasures beyond our wildest dreams. Legends of great wealth being buried with kings or even great golden cities such as Eldorado have focussed the efforts of grave robbers the world over.

When the pyramids were first excavated by Westerners, their preferred method was dynamite. These days we may be more attuned to the delicacy of archeological exploration, but many of the exquisite sculptures and artifacts that were so carefully concealed within ancient walls now have pride of place in private collections, or have been damaged beyond recognition.

The treasures that have survived give us a tiny but unique insight into the lives of their creators, yet many are hidden away in dusty vaults and have never been properly examined. It is remarkable that such extraordinary pieces of history as the wooden airplane model in the Cairo Museum could have been misfiled for so many years and only rediscovered by pure chance.

Instead of making grand assumptions based on our own current value judgments, which led to the above-mentioned artifact being categorized as a crudely carved "bird," many researchers feel it is time to reassess our ancient history in the light of what we now know.

The evidence we have before us is precious and deserves to be evaluated with respect. It is perhaps too soon to make sweeping statements affirming that our ancestors were visited by aliens from another planet, but it is not too soon to admit there are pieces of our history that we just don't understand.

Not only are these artifacts works of art in their own right, but they were crafted by cultures, that if not literally alien, are alien to our modern 20th-century society. They conceal fabulous tales of vengeful gods, giants, fire-breathing flying sky beasts, and man's struggle for survival. They also contain evidence that man had intricate medical, scientific, and possibly even aeronautical knowledge. It is time these vital clues were retrieved from the museums and re-examined. If ancient man could build airplanes, complex drilling machines and was able to harness electricity, then where did he learn how to do it? Even more importantly, how was this knowledge lost?

One of the strange heads from the Olmec culture featuring a "helmet."

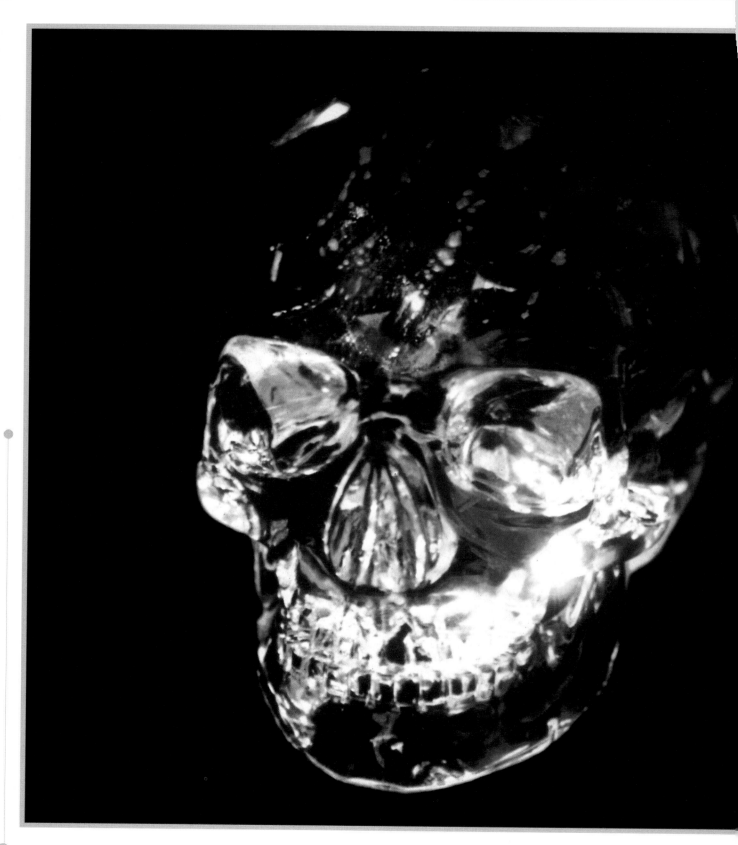

Crystal skull discovered in British Honduras by Anna Mitchell-Hedges in 1927.

CRYSTAL SKULLS

One of the most ornate and beautiful forms of alien art that still puzzles researchers are the famous crystal skulls unearthed in parts of Mexico and Central America. These crystal skulls, found near the ancient ruins of Mayan and Aztec civilizations (with some evidence linking the skulls with past civilizations in Peru), are believed by some ufologists to be linked with extraterrestrial visitors.

The most famous of the skulls, the Mitchell-Hedges skull, was discovered buried within Mayan ruins in Belize in 1927. A picture taken from below the skull is said to reveal an alien craft within the crystal, and even more mysteriously, certain music and colors can allegedly trigger hologram-like images of the UFO which radiate from the skull.

The skulls are not identical: crystal skull researchers believe some are older than others and a few of these skulls have more pointed heads. One, known as the Amethyst Skull because it is carved from a very dark purple amethyst stone, has an extraordinarily elongated brain case and seems to bear an uncanny resemblance to modern drawings of the "Gray" species of alien.

There are many theories about crystal skulls, one of the most romantic being the idea that only when all the skulls are discovered and reunited, will their purpose become clear. Unfortunately, as with many of these ancient Earth mysteries, modern archeologists and scientists will need to approach this quest with more of an open mind than they seem to possess at present.

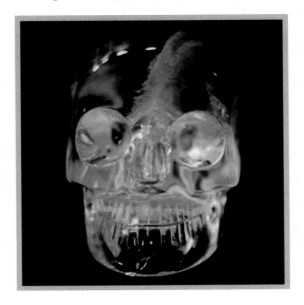

Crystal skull discovered in 1935 in the Mayan ruins of Lubaantún in Belize.

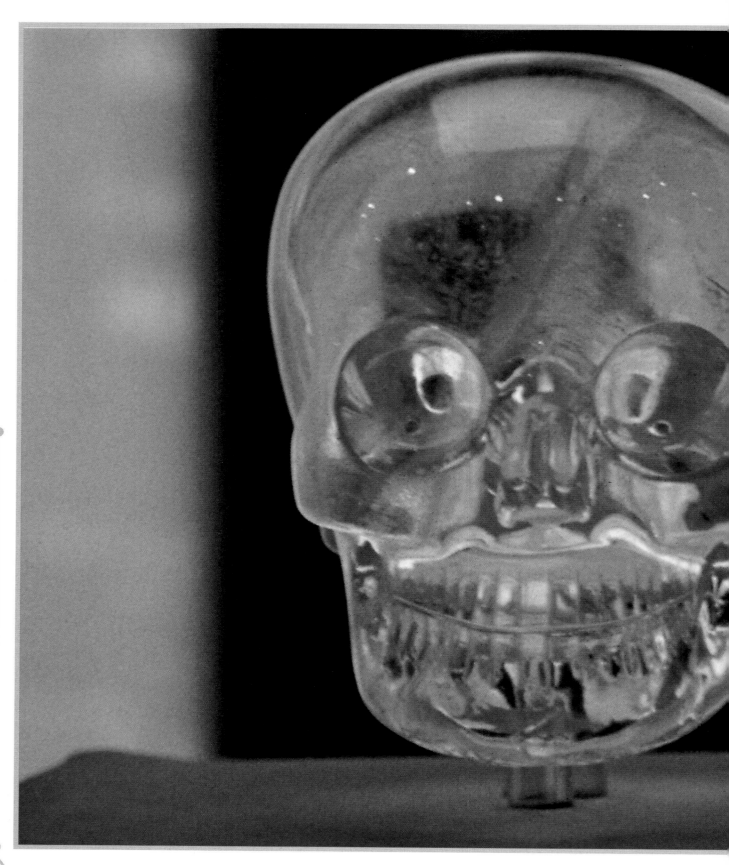

Old Native American legends and ancient Mayan prophecies are surprisingly similar in their stories about these fascinating crystal skulls. According to their traditions, there are 13 "genuine" skulls which were brought to Earth by extraterrestrial visitors in our past. These 13 are believed to contain important information for mankind; some stories even relate that the skulls can speak. The two diverse, ancient cultures also agree on a date when the skulls will be reunited and their message will be revealed—2012.

When the Mitchell-Hedges skull was tested by scientists at Hewlett-Packard, they were baffled as to how and when it was made, but they did say it could generate electricity! They also noted that today's technological advances in the field of computers often rely on crystal-based research. The implications are that if an alien race did deliver these extraordinary sculptures to our planet, then they possibly contain a coded message stored in a way we cannot yet unscramble.

There have been numerous reports of psychics and mediums working with the crystal skulls and "feeling" an inexplicable force. Others have insisted that the skulls have healing properties: "ET", a smoky-colored skull, is regularly taken to healing events by its owner Joke Van Dietan because she claims it nurtured her after she suffered from a brain tumor.

Others are not so sure that the skulls' power is benevolent. Often referred to as the Skulls of Doom, the sinister side of these strange creations cannot be ignored. In their book *The Mayan Prophecies*, Adrian G. Gilbert and Maurice M. Cotterell speculate that the Mitchell-Hedges skull could have been used by priests as a glass to reflect the sun and create fire. The result would have certainly been an immense and frightening show of power. Other Mayan legends allegedly link the skull with impending death. A priest simply had to command the skull to help him bring someone to his end and the skull would oblige.

This splendid skull, carved from rock crystal, is possibly Aztec, circa AD 1400–1500.

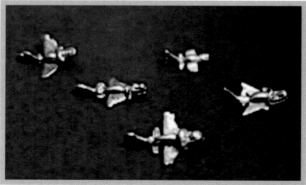

The "Delta aircraft" models (above), found in a Colombian tomb. They were previously cataloged as fish, moths, or butterflies. At the Ancient Astronaut Society Conference in 1997, two German researchers revealed an exact copy of the planes which when propelled into the air, astounded onlookers by actually flying (top).

AIRPLANE ARTIFACTS

When Dr Ivan Sanderson examined an ancient South American gold artifact which had previously been thought to represent a moth or bee, he couldn't help but remark on the similarity of the 1000-year-old model to a modern airplane, particularly a jet fighter. Charles Berlitz, in his 1972 book *Mysteries From Forgotten Worlds*, recounts how the artifact was shown to German fighter pilot and engineer, J. A. Ulrich. Ulrich was told nothing about the gold object, but came to the conclusion it was an F-102 fighter: "He observed the rudder was conventional and that features at the end of the model might be speed brakes instead of elevators, the lack of rear elevators being a shared feature with the new Swedish SAAB aircraft."

There is no doubt about the dating of the little gold artifact, but many conventional scientists still refuse to accept that it is a model of a flying machine—and an extremely modern one at that! The Ancient Astronaut Society, an international group of like-minded researchers, has adopted the Colombian plane as an emblem for the society. Its design is so obvious that it seems incredible we are ignoring its significance. Could it mean our ancestors had the technology, or at least knew of those who did, to fly above the Earth's surface?

The Cairo Museum in Egypt holds an equally bizarre exhibit discovered at an archeological dig in Saqqara. In 1969 Dr Messiha found what he believes to be a representation of a plane in a box of ancient bird models in the museum's store room, but the little wooden artifact is certainly not a bird. Messiha notes that it is a perfect scale-model of a glider and that the Ancient Egyptians made models of all their contemporary technology, it is just that this time we have yet to find the real thing.

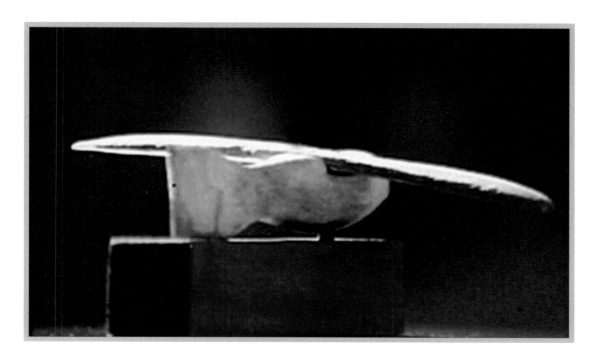

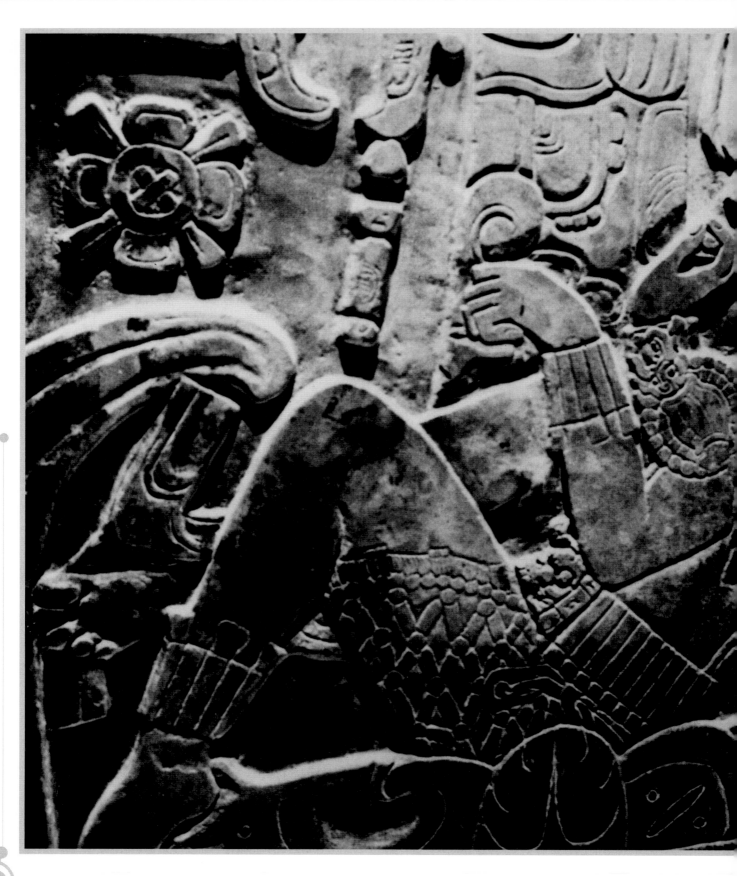

PALENQUE TOMB

Erich von Däniken believes the Palenque Tomb could be the ultimate proof that extraterrestrials visited Earth. The sarcophagus was discovered in 1952 in the Temple of Inscriptions at Palenque, Mexico. When the lid was examined it revealed an extraordinary carving which, say supporters of the Ancient Astronaut theory, shows a man steering a rocket. Indeed, the carving has provoked much discussion, as the "rocket" does look remarkably like a modern form of transportation, complete with steering mechanism, pedals, and some form of navigating system.

More recently, in his extraordinary book *Gods of the New Millennium*, Alan Alford says the carving is more likely to be a depiction of a complex boring device or earth-moving equipment, supporting the idea that the "flesh and blood gods" gave early man extremely advanced technical knowledge which has long since been forgotten.

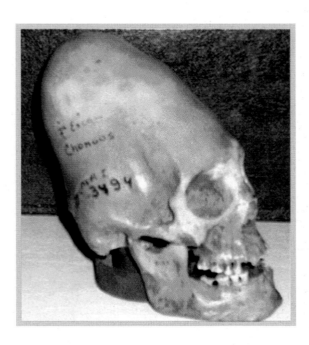

Von Däniken argues that the extraterrestrial gods genetically interfered with mankind, possibly more than once during our evolution. The space gods ensured they bred an intelligent, technically advanced race that resembled themselves. This bizarre skull, found in Mexico in 1926, is a genetic mistake according to von Däniken, possibly containing too much alien DNA.

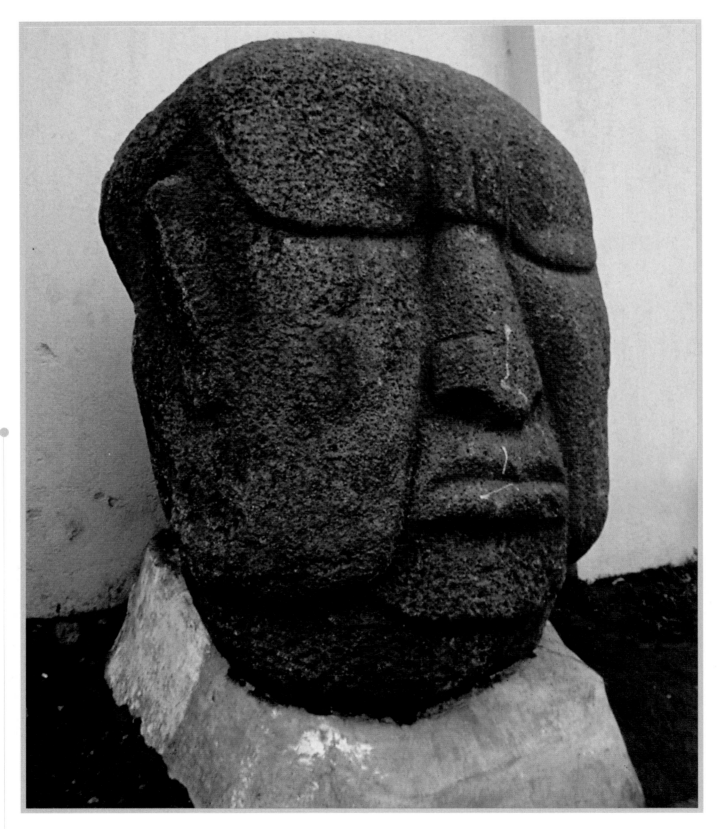

The Olmecs are thought to have been the first civilized people of Central America and they are renowned for their extraordinary artwork—most of which depicts these strange, yet simplistic heads with helmets.

OLMEC HEADS

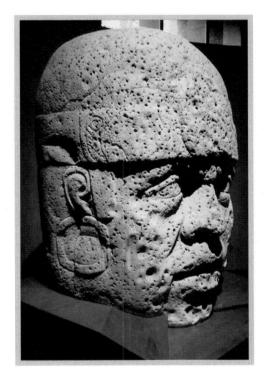

The Olmec culture, currently dated to around 1400 BC and based in Mexico, causes historians some major problems. Although some 40 settlements are thought to have existed, few have been excavated properly. What is certain is the existence of 16 giant carved heads (although it is presumed that more heads await discovery), all wearing some kind of protective headgear and showing distinctly African facial features.

Many more partly finished heads have been discovered, which suggests whoever made these strange sculptures left the area quickly. Researcher Alan Alford thinks vital clues to unlocking the mystery of man's past could be hidden within the remnants of this little-understood culture, who transported these heads, some weighing 30 tons, over long distances. He maintains the headgear on the carvings is some form of "protective helmet ... highly indicative of a mining helmet," which he says indicates a "primitive" culture possessing high technology. Others have claimed the helmets are remarkably similar to astronauts' space helmets. Did the gods need protective clothing to survive the trip from their planet to ours? And if so, are the Olmec heads carved in their image?

An Olmec head on display in the National Museum, Mexico City, Mexico. Carved from basalt, the head shows a distinctive helmet which has provoked considerable controversy.

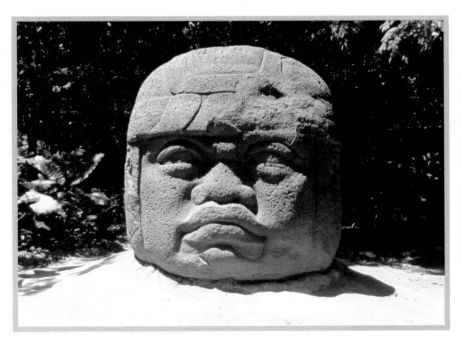

This 3000-year-old Olmec head has been put on display at La Venta Park, Villahermosa in Mexico. It weighs 24 tons and is approximately seven feet high.

BAGHDAD BATTERY AND AZTEC ROCKET ENGINE

What did this replica of an Aztec basalt carving really represent? Its proportions are exact and certainly look more like a complex piece of technology rather than a representation of anything natural.

In 1938 Dr Wilhelm Konig discovered an extraordinary archeological find buried at Kujut Rabua in Baghdad, Iraq. Resembling earthenware pots and dating back approximately 2000 years, what Dr Konig had in fact discovered were electrical batteries! Brad Steiger describes the discovery in his book *Worlds Before Our Time*: "each contained a cylinder of sheet copper 5 inches high and $1^{1}/_{2}$ inches in diameter. The edges of the copper cylinders were soldered with a 60-40 lead-tin alloy ... the bottoms of the cylinders were capped with copper disks and sealed with bitumen or asphalt. An additional insulating layer of bitumen sealed the top and held in place iron rods which were suspended into the center of the copper cylinders and bore evidence of having been corroded by an acid solution."

Researchers have found that replicas of the ancient pots can generate between $1^{1}/_{2}$ and 2 volts of electricity! Considering Europeans didn't harness electricity until AD 1800, how did our ancient ancestors discover this power force? Surely this is an evolutionary hiccup?

The copy of an Aztec basalt carving (National Museum, Mexico City, Mexico) shown in the main picture bears an uncanny resemblance to a modern rocket engine. If, as some researchers have suggested, we only know about 10 percent of our ancient history, isn't it time we at least examined these clues with an open mind? Electricity, rocket engines, giants with space helmets, and highly advanced ancient cultures—does it all begin to add up?

This innocent looking pot turned out to have all the ingredients of a modern-day battery—only it is almost 2000 years old!

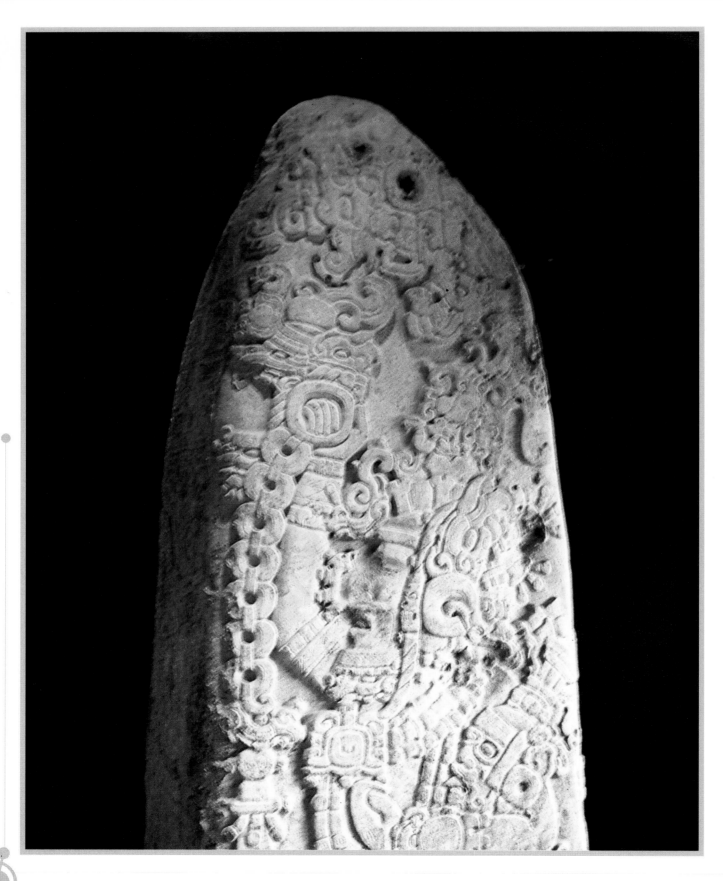

TIKAL STELAE

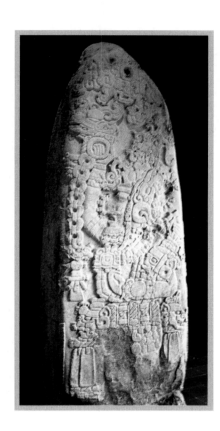

Tikal, at its height of Mayan popularity, was an important city with approximately 10,000 inhabitants. Today the ruins stand in the middle of the Tikal National Park in Guatemala and act as a sightseeing tour for visitors. The significance of the city is manifold; it's a complex system of temples, palaces, reservoirs, and even ball courts, paying homage to the advanced civilization that lived in the 3000 different buildings. The temple of the giant Jaguar, which is at the center of Tikal, has been dated to AD 870 and towers 145 feet into the air. Tikal is probably one of the best-preserved Mayan cities, and because of this, it reveals some secrets of our past.

There are approximately 200 stone monuments (stelae) at Tikal, mostly placed in temple courtyards. They are almost unique to this area, and have intricately carved faces. Ancient Astronaut theorists have studied the carvings and agree they bear remarkable similarities to the Palenque Tomb (see pages 64–65), perhaps revealing further clues about our ancestors' understanding of an advanced technology.

Are the Mayan stelae at Tikal records of our ancient history, rather than the ornate works of fiction which is the popular belief?

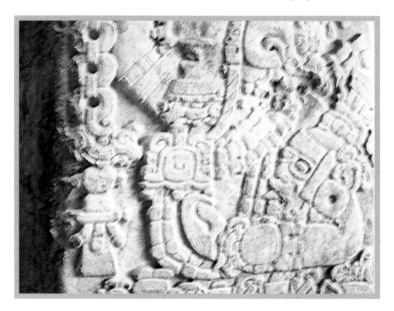

One of 200 stelae at the beautiful ruins of Tikal in Guatemala. The elaborate carvings tell a detailed story of everyday life governed by an unknown force or gods.

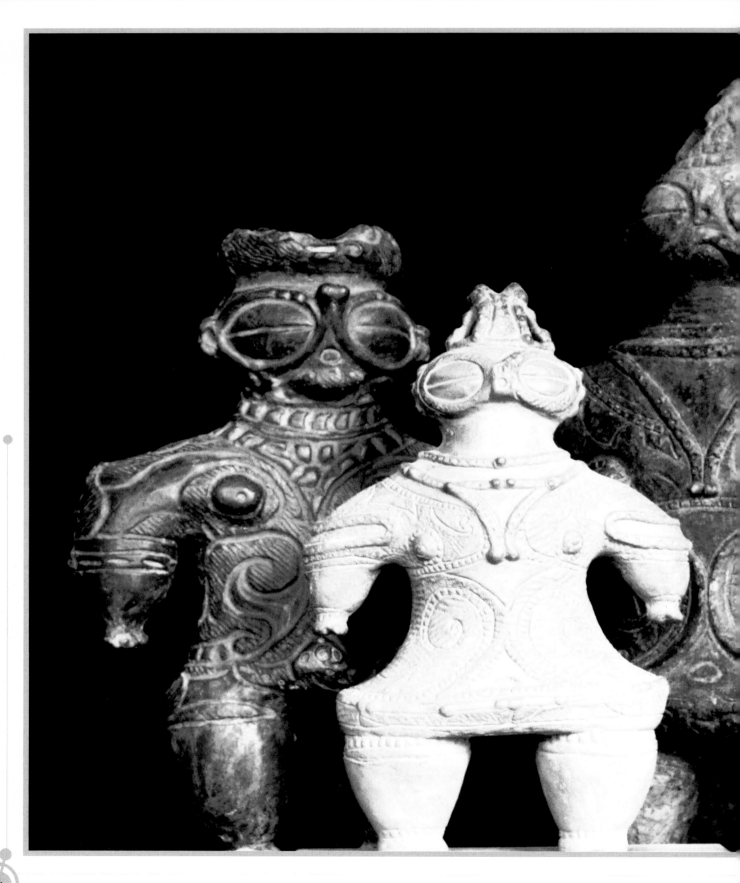

JAPANESE FIGURINES

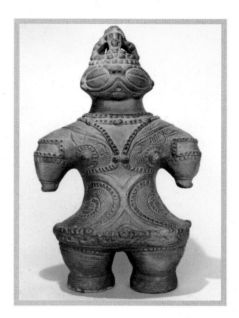

There are many artifacts from around the world that Ancient Astronaut theorists have pounced upon and claimed they are indeed representations of ancient spacemen. The more conservative of us would admit that they do resemble beings that are now alien to us, but that does not necessarily make them aliens. However, only the most narrow-minded of us could refuse to admit to being puzzled by artifacts such as these bronze statues from Japan.

Believed to have been dug up on the island of Hondo, no-one knows just how old these strangely clad figures are. Their "spacesuit" garments, complete with helmets, are remarkable in themselves as this is by no means typical to ancient Japanese art, but the real mystery is in the eyes of the figurines.

The eyes of the statues are covered with something resembling modern skiing goggles, but must have had some other significance when they were carved. Why would ancient artists have gone to so much trouble to represent these unknown figures with protective eyewear? To understand the figurines, it is essential to understand the artist who carved their unusual forms. Who or what was the inspiration for these suited figures with sci-fi eyes?

Could these strange-looking figurines, recovered from the Japanese island of Hondo, be representations of alien visitors wearing spacesuits?

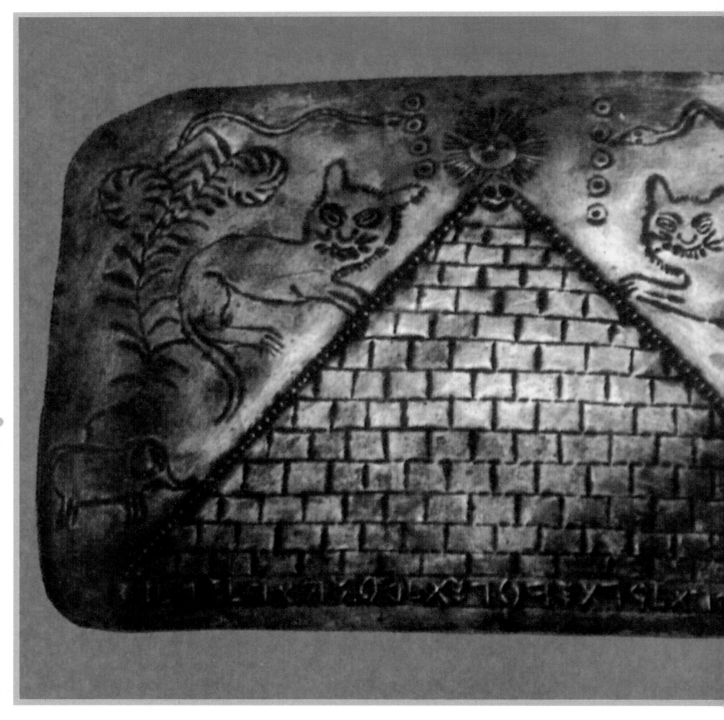

Ancient gold treasures discovered in deep tunnels below Ecuador and Peru are undoubtedly records of a previously undiscovered civilization, but are the links to Egypt and the heavens merely coincidence, or is it time we seriously questioned the origins of our master-craftsmen ancestors?

MAYAN PYRAMID ART

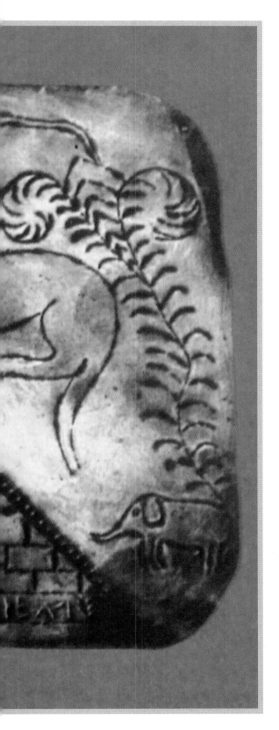

In his book *Gold of the Gods*, Erich von Däniken wrote of a fascinating encounter with Father Crespi from Cuenca in Ecuador. Crespi has lived in Cuenca for most of his life and has become the trusted guardian of a vast collection of Indian treasures. Von Däniken was shown a wealth of solid gold plaques with pyramids depicted on them. He counted hundreds containing images of suns, animals, and snakes, which he believes are records of visitors from the stars.

The plaque depicted opposite has the typical pyramid shape common to the group and depicts the sun, flying serpents, big cats, an unidentified form of writing, and elephants.

All the pyramids embossed on the gold plaques have pointed apexes, which is strange if one considers that the artists who created these metal records were supposed to be the same peoples who constructed the flat-topped pyramids of the Mayan and Inca cultures. Why do these representations of pyramids found in South America accurately depict those on the sands of Egypt?

Researchers have also wondered at the significance of the flying snakes, which many believe are depictions of airborne gods, but the strangest enigma of all is the elephants. The idea of elephants in Ecuador is preposterous now, but, says von Däniken, they were present in South America "about 12,000 years ago, before any civilizations or cultures are supposed to have existed," and indeed archeologists in the area have found evidence of bones. This, says von Däniken, means the gold plaques are much, much older than was previously thought. They date back to a forgotten culture whose existence throws our current evolutionary theory into disarray.

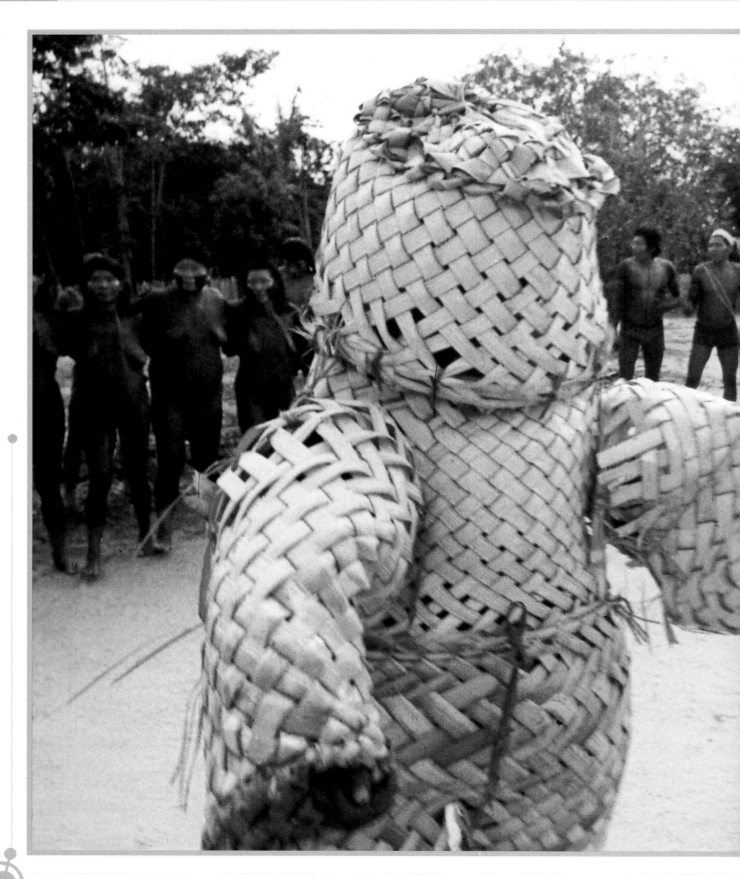

KAYAPO INDIAN RITUAL GARMENTS

In *Gold of the Gods*, Erich von Däniken published this extraordinary picture of the Kayapo Indians. The photograph was taken by Dr Joao Americo Peret in 1952 when he visited an Indian village on the upper Amazon River in Brazil. Von Däniken excitedly claims the picture needs "no commentary," believing that the outfits, which are worn in a ritual to celebrate the appearance of Bep Kororoti (a benevolent sky god) are replicas of the extraterrestrial's spacesuit.

Bearing in mind that spacesuits are allegedly a modern invention and that the Kayapo not only had never seen them, but had also been making and wearing these elaborate costumes for as long as they could remember, we should be asking ourselves what influenced the extraordinary design.

Kayapo legends say Bep Kororoti arrived wearing this suit and even when he became the people's teacher, he would occasionally wear it to overcome problems or to make himself understood by tribe members.

The medicine man adopts the persona of the visitor from the sky who arrived wearing a spacesuit and taught the Kayapo how to make more sophisticated weapons and how to farm more successfully. Legend has it that he also promised to return one day.

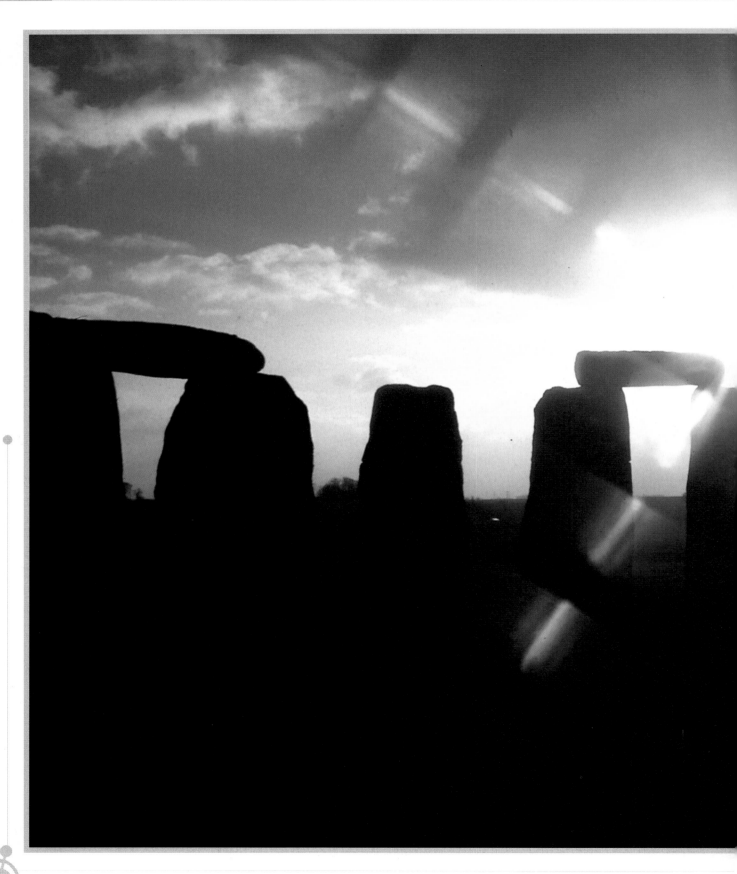

CHAPTER FOUR
ANCIENT MONUMENTS

Our planet's surface is littered with the remnants of our ancestors. Nowhere is man's passage of time more dramatically indicated than in Egypt, where the modern hustle and bustle of 20th-century life is played out against a backdrop of some of the most ancient and awe-inspiring monuments in the world. Today we take images of the pyramids and of Stonehenge for granted. We are so used to seeing these huge monuments that we don't question their very existence. We fail to marvel at their enormity, their age, or their construction.

Many of these ancient monuments had a practical purpose that was outside everyday use. Stonehenge, for example, is an accurate calendar system and was used to time the passing seasons and years. Its positioning was crucial and complex, and its dimensions were obviously very carefully planned.

Other monuments, such as the famous Easter Island statues, remain a mystery. Hundreds of these strangely carved giants stare determinedly out to sea as if waiting for something. Their positioning appears to be random, yet some of the figures form definite groups.

All of these monuments have one thing in common—we do not know who built them. Most are thought to have been constructed at a time when "civilized" societies are not supposed to have existed, yet they all bear testimony to artists who had great technological skill. These anonymous builders somehow had the power to cut huge granite blocks with a precision that we find hard to replicate today. They could carve perfect giant stone spheres, they developed metal hinges, they may even have harnessed the power of levitation as conventional explanations of how such heavy blocks were lifted are simply inadequate.

How did man suddenly develop these powers? It is time we once again wondered at the magnificence of our ancient monuments.

All these structures contain a silent significance that we can only begin to understand. Not only did most of these monuments have some sort of purpose, but their designs and positioning also represent an important part of their creators' beliefs. Most seem to have a link with the skies—be it the stars, the planets or unknown "gods." They are huge, almost indestructible shows of strength and power, yet we have so little understanding of how and why they were built.

Was there an ancient civilization that we have yet to discover? Did travelers visit us from another planet? Are these monuments much older than we previously thought?

Stonehenge, England, one of the world's most mystical sites.

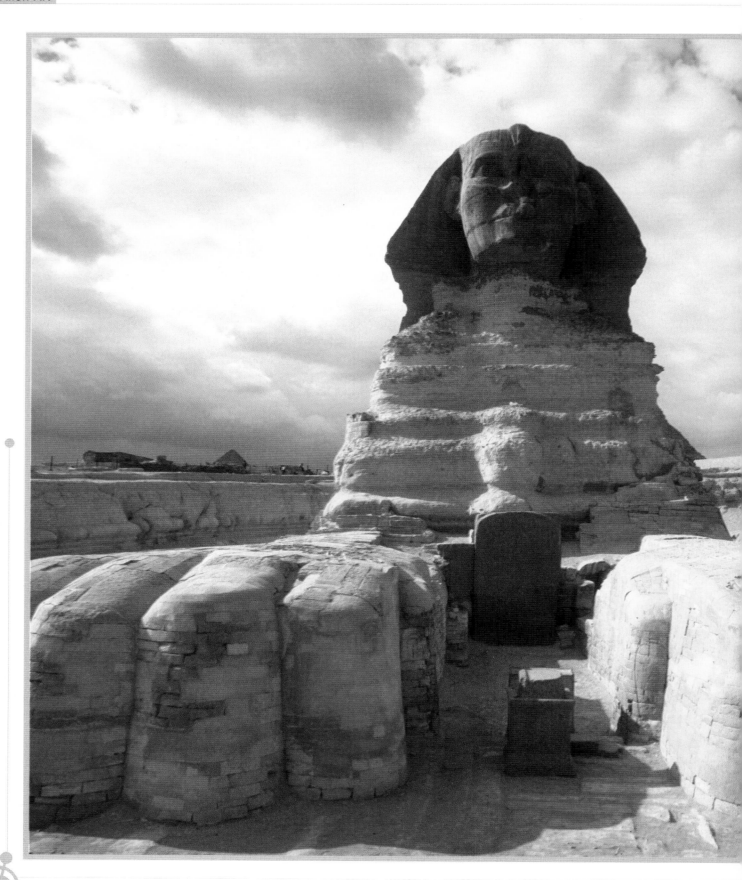

EGYPT: DATING THE SPHINX

The Kingdom of Egypt (3200 BC to AD 300) left the most inspiring and spectacular structures of any known ancient civilization, the most famous of which is the Sphinx. According to our conventional view of ancient history, the 240-foot-long Sphinx has sat proudly guarding the pyramids of Giza for 4500 years. Built by King Chephren, the man–lion hybrid is supposed to symbolize the immense power of the divine ruler.

However, this accepted dating which fits perfectly into our linear evolutionary theory could be about to be turned upside down. John Anthony West, author and independent Egyptologist, has caused a storm with his controversial theory that the Sphinx is much older than previously thought, maybe dating as far back as 15,000 years.

The basis of West and his team's work is that the erosion on the solid limestone structure of the monument has been caused by water—by prolonged exposure to rain. West employed the help of American geologist Robert Schlock. The geologist was skeptical at first, but after visiting the site he announced that the Sphinx, the enclosure it sits in and the two temples built with the stone removed from its enclosure, all portray classic textbook signs that they were eroded by water.

Climatologists believe the desert hasn't had a significant rainfall for 10,000 years, which makes the Sphinx at least twice as old as Egyptologists would still have us believe. According to their records, Egypt was populated by primitive hunters 10,000 years ago, not by a highly civilized society who could construct great monuments from 200-ton blocks of stone. So who did build the Sphinx?

Contemporary drawings explaining the construction of the Sphinx depict thousands of slaves moving gigantic blocks of stone on simple wooden rollers, in much the same way as the construction of the Easter Island statues and Stonehenge are explained. However, if even our modern technology would have problems constructing such monuments, can we believe our ancestors really relied on such primitive and inefficient methods?

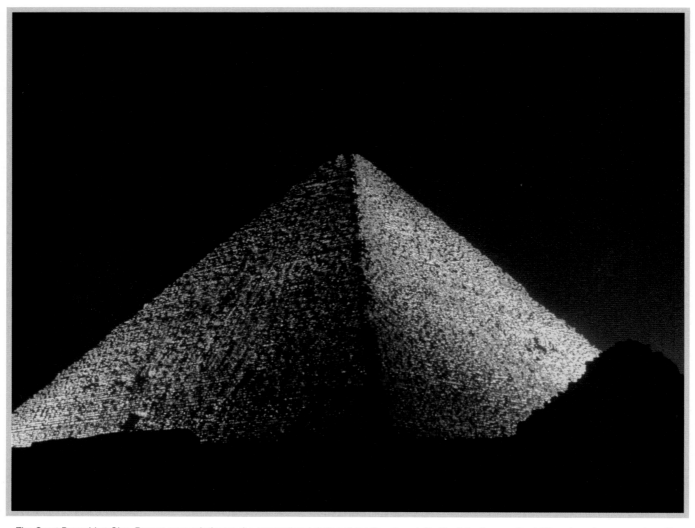

The Great Pyramid at Giza. Recent research throws the conventional dating of the Egyptian civilization into disarray. Could there have been a much earlier civilized race in northern Africa?

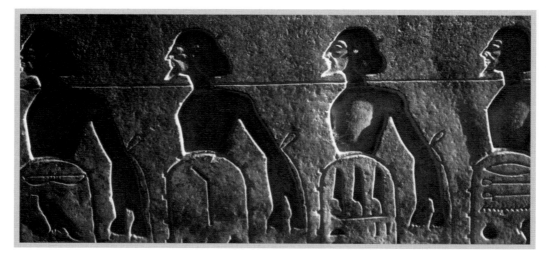

Could these strange monuments be linked to a 15,000-year-old Sphinx and a forgotten race of peoples from the first civilization called Atlantis?

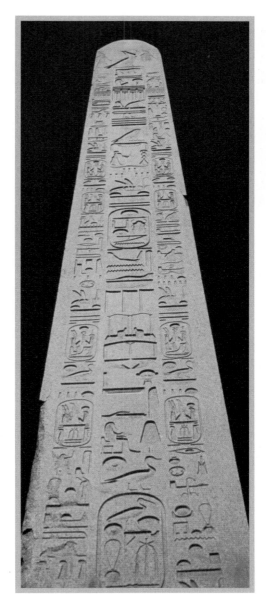

When the 1979 Viking expedition accidentally photographed a strange "face" on the surface of Mars, was it just a bizarre coincidence that it resembled a human–lion hybrid? Was it also coincidence that situated in the same Cydonia region of the planet was a clearly defined, five-sided pyramid rising proudly from the red dust?

The pictorial records of the Ancient Egyptians give us clues about their belief system, especially relating to their kings and queens. The ruler was thought to be a flesh and blood incarnation of the sky-god Horus. When he died, his progress back to the skies was helped by the relationship of his pyramid to the sun.

John West's initial study, *Serpent in the Sky*, has been a catalyst for further analysis of the Sphinx and its surrounding area. Some researchers have hypothesized that the water erosion of the monument was caused by the Great Flood, and that the Sphinx itself was built by survivors of that great mythical culture, the Atlanteans.

West believes that whoever this ancient advanced culture was, its people had technological knowledge at their disposal that we have yet to rediscover. Some of the blocks removed from the Sphinx enclosure and used to build the two nearby temples weigh almost 200 tons. We know that the Ancient Egyptians had a developed understanding of sound, because certain pillars resonate like giant tuning forks, but is it possible that their ancestors could harness soundwaves to levitate huge building blocks? Scientists in the 20th century have in fact captured sound between two reflectors and have used it to levitate tiny stones—so perhaps this isn't such a far-fetched idea.

One of the most fascinating mysteries that has been given credence thanks to West's research, is the verification of a bizarre claim by the infamous medium Edgar Cayce. Shortly before he died, Cayce had a dream which he said revealed that a hidden chamber under the Sphinx's paws held the secrets of mankind's past, and when explored it would reveal the records of the ancient peoples of Atlantis. Seismological studies of the ground surrounding the Sphinx have revealed that there is indeed a chamber under the paws and its precise rectangular proportions strongly indicate it is man-made. Permission to excavate has so far been denied.

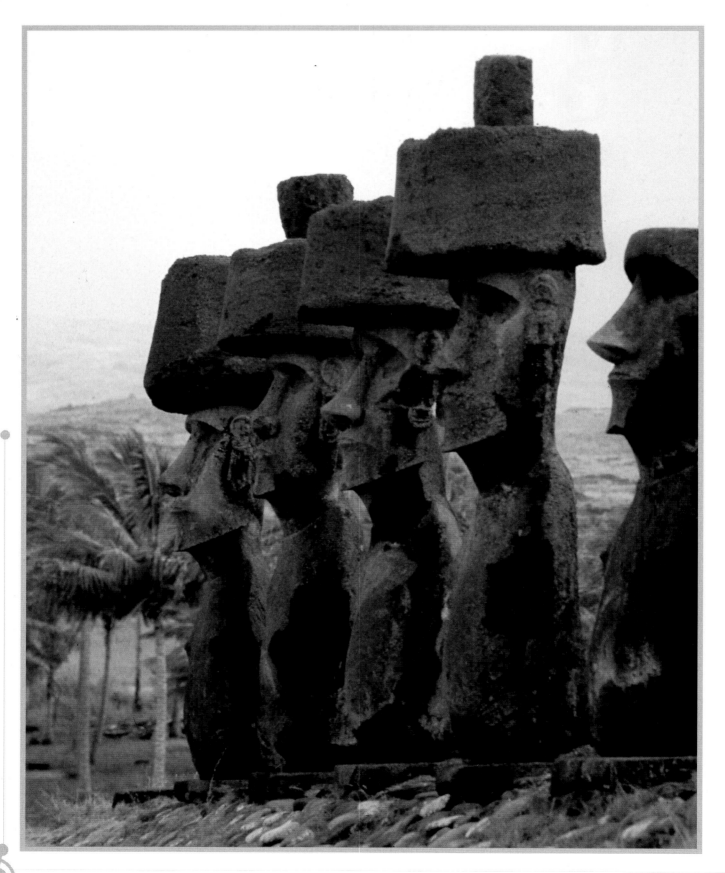

EASTER ISLAND STATUES

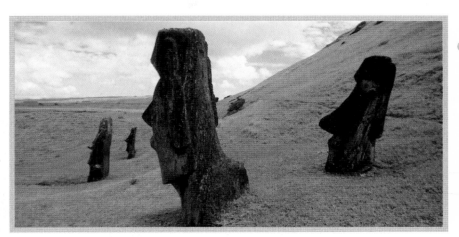

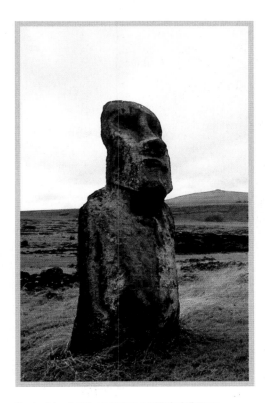

Easter Island statues restored with their "space helmets" to look as they appeared to the first Western visitors. The island inhabitants say they have no idea how the statues were made or who made them. However, an ancient "myth" that has survived is of their gods arriving in a giant egg-shaped craft. Was this an extraterrestrial flying machine?

Easter Island, an inhospitable volcanic island in the Pacific, has perplexed archeologists and historians since its discovery by the Dutch in AD 1722. All the evidence points to a civilization that had advanced technology at its disposal. The 300 finished giant statues that line the coastline, looking out to sea, still silently refuse to reveal who made them and for what purpose.

Recent attempts to replicate the building and moving of the 30-ton statues has resulted in failure. As with Stonehenge, history books generally say the immense effigies were moved across the harsh terrain on wooden rollers.

Erich von Däniken believes that somehow a group of extraterrestrial visitors became stranded on the island and they taught the native inhabitants how to carve intricate designs with some advanced form of laser device. When the first Westerners approached the island, the severe-looking statues wore red helmets that had been carved separately and raised (sometimes 60 feet) on top of the effigies. They also had wood panels around their necks with a still-indecipherable language on them. Mysteriously, the wood had somehow been imported from elsewhere.

Were the statues made in the image of the extraterrestrial visitors, so that their own race would find and rescue them? What is certain is that whoever the mystery craftsmen were, they left suddenly, abandoning 200 unfinished statues in the quarry, one of which would have been a massive 164 feet high.

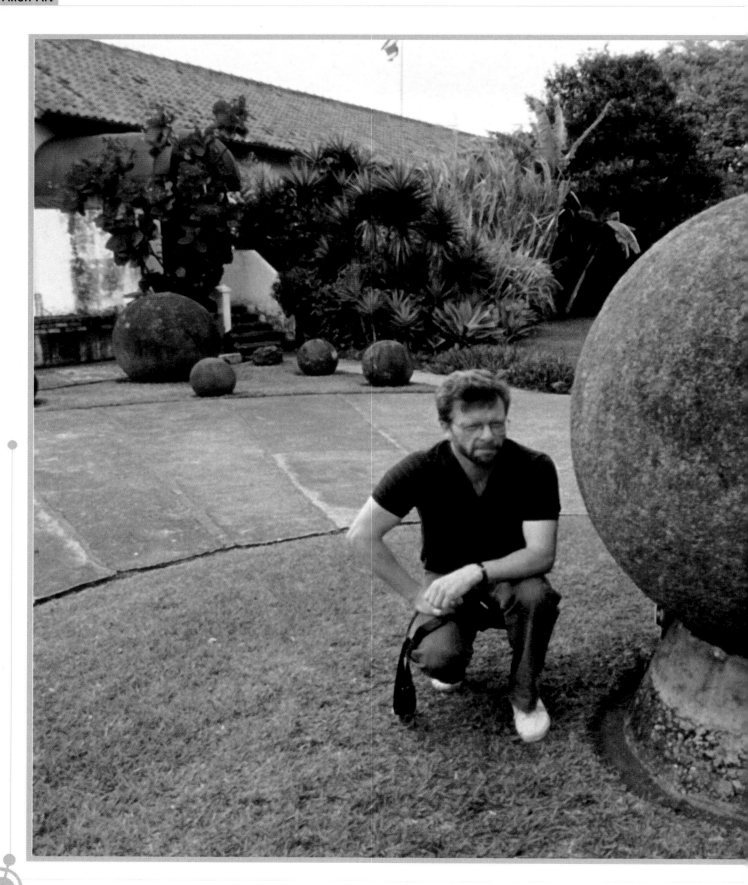

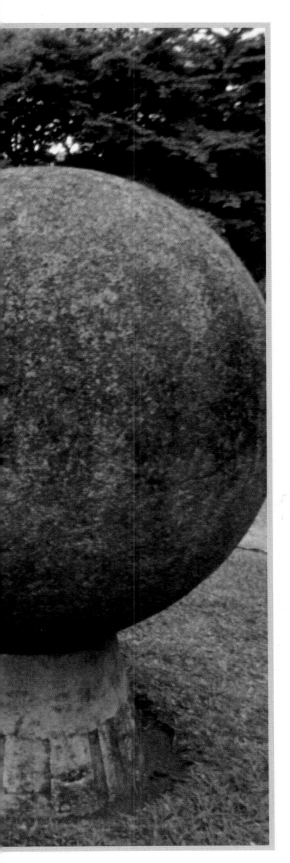

COSTA RICA BALLS

The Central American state of Costa Rica has a megalithic riddle all of its own. Hundreds, if not thousands of geometrically perfect stone spheres lie hidden in the jungle, on mountaintops and near rivers. Their precise nature and sheer size (the largest weighs 8 tons) has baffled scientists. Who made the balls is unknown and their purpose is a complete mystery, but there could be a clue in that the natives refer to them as "sky balls."

Local legends have arisen which say the balls contain a center of gold, and this has led to many being moved and smashed open, but they have all proved to be solid granite. Another mystery is that a quarry has never been found, so where did the balls come from?

Could the balls be connected to the spherical spaceships which certain followers of the Ancient Astronaut theory have said is the perfect shape for interstellar travel? Once again, could the native Costa Ricans hold the clue to a hidden history which has remained buried for far too long?

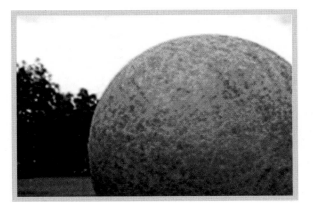

Strange stone spheres from Costa Rica, made by an unknown culture. They vary in size from having the diameter of a soccer ball, to being larger than a man. Many more are thought to lie hidden in the dense jungle.

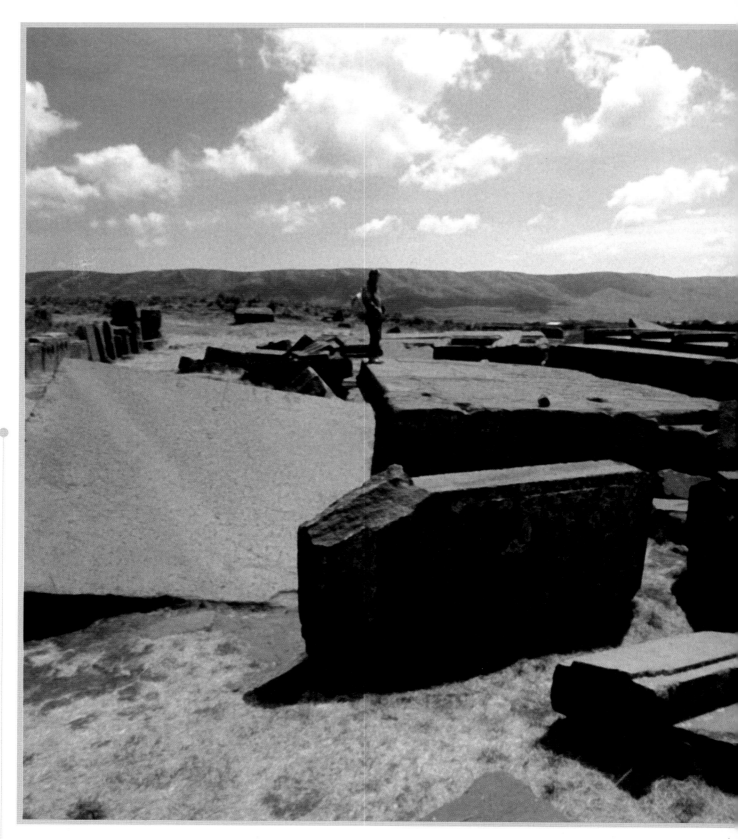

The impressively worked stones at Puma Punku are an extraordinary legacy left by a technologically advanced culture.

PUMA PUNKU STONES

Puma Punku is a mile away from the settlement area of Tiwanaku, high up in the Bolivian mountains. Although the Incas later populated the site, there is evidence that it was built much earlier by a highly sophisticated race of master craftsmen. Whilst Puma Punku is in ruins, the stones have extraordinary qualities. Most are huge blocks which would have been near-impossible to move, although they are not quite in the same league as the Baalbek stones (see pages 96–97).

Narrow, long grooves, and minute drill holes are evident on one of the most impressive examples, while other stones have markings that suggest they were joined by metal hinges or brackets.

After examining the evidence drawn from sites such as Puma Punku, Maurice Chatelain, a NASA aerospace engineer, surmised in his book *Our Ancestors Came From Outer Space*, "Our ancestors knew and used static electricity, electric current, wet-cell batteries, electric plating and powerful light projectors fed by high-voltage cables. They used platinum, a metal that melts only at 1753°C, and aluminum, which allegedly wasn't discovered and produced in quantity until the 19th century."

Puma Punku's existence causes a real hiccup in conventional evolutionary theory. The ancient, gifted stonemasons didn't develop all these talents overnight—they were perhaps taught them.

An example of the hard andesite stone, worked with extreme accuracy by an unknown culture. Some researchers have speculated that our ancestors may have used lasers to carve through these rocks with such precision.

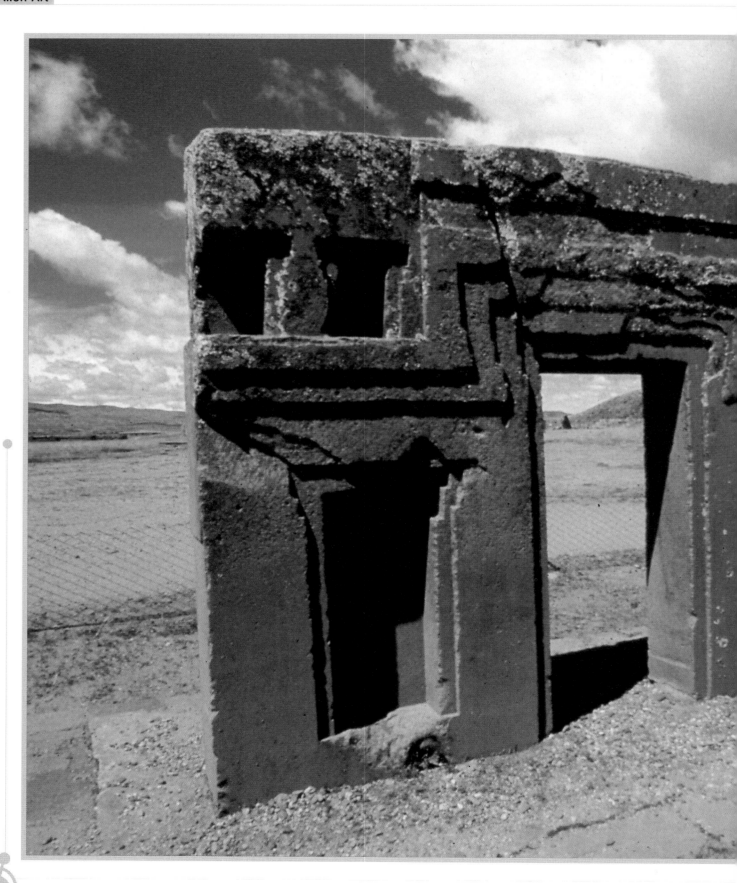

GATEWAY OF THE SUN

Another example of the incredible and inexplicable architecture of Tiwanaku is the Gateway of the Sun, which although only 9 feet tall, has been carved from a single block of stone. Despite the corroded state of the monument itself, the carved "windows" and corners appear to have been created using modern-day tools—they are remarkably accurate and even the indentations, which are still difficult to achieve from solid hard rock, have perfect corners.

Peter Kolosimo discusses the date of the site in his book *Timeless Earth*. He writes that Arthur Posnansky, an anthropologist and engineer who made a detailed study of the area, believed that the settlement was constructed several times, the last time being approximately 16,000 years ago. Posnansky believed the Gateway of the Sun is 18,000 years old.

The Incas retold ancient legends that even before man had populated Tiwanaku, the gods built their initial base on the site, using advanced technology. Spanish records written by the conquistadors speak in awe of the wonderful architecture of the South Americas, but none give any clues as to its origin.

The Gateway of the Sun is carved from a single block of the hard andesite stone that made up the impressive complexes of temples, dwellings, and fortifications at the site. It is estimated the monument weighs between 10 and 15 tons.

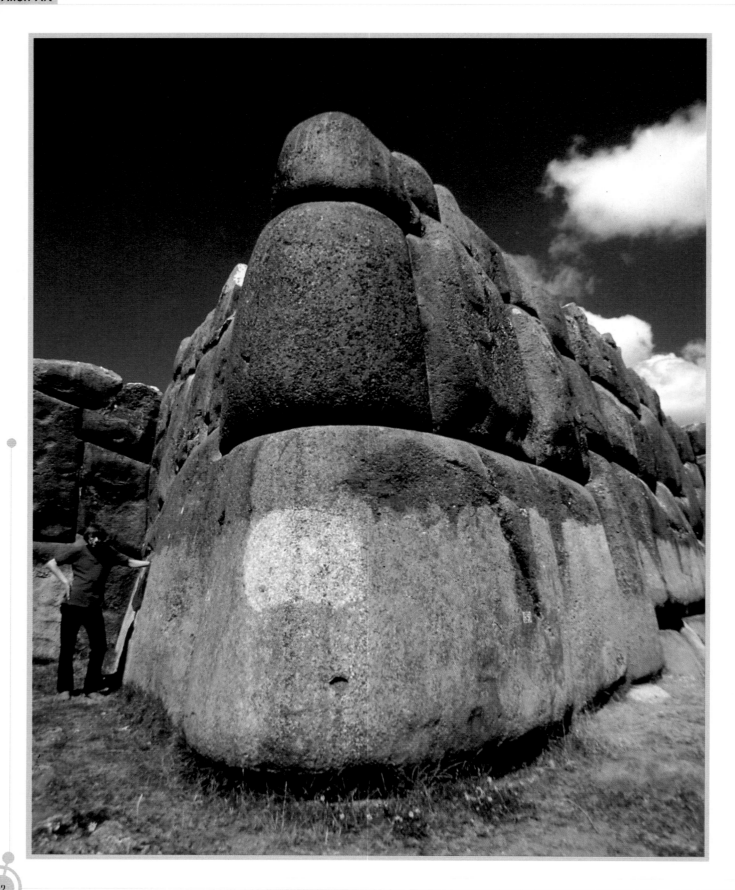

SACSAYHUAMAN STONES

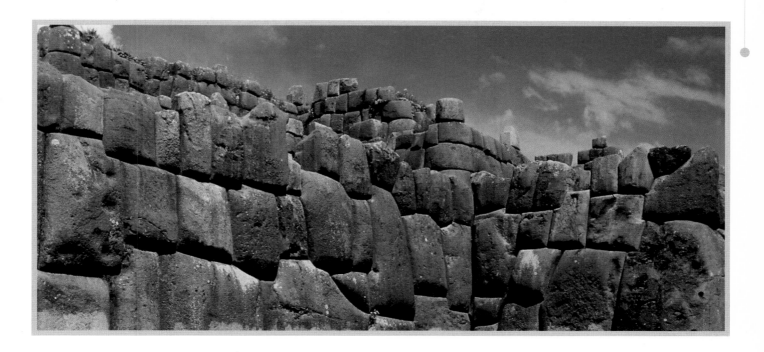

The magnificent megalith of Sacsayhuaman. Alan Alford, in *Gods of the New Millennium*, wondered why the stonemasons hadn't used smaller stones which would have been far less dangerous. Perhaps the construction technique was simple to this unknown culture? Maybe they had technology available to them that will only occur again in our future?

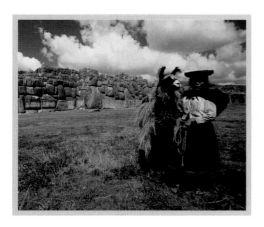

The incredible walled structures at Sacsayhuaman, near Cuzco in Peru are thought to be ancient fortifications and have been described as one of the most awesome monuments on Earth. Today, they stand silent and defiant at a breathtaking altitude of about 3500 feet, as invincible as ever.

The giant stones are held together with nothing but their weight and careful construction. The largest stones are 20 feet in height and weigh over 100 tons! It is understandable that some archeologists have dismissed the traditional view that the shaping of the blocks was done with "primitive" tools, and have suggested theories as controversial as levitation and laser beams. When the rounded surface and perfect fit of connected stones is analyzed, the construction seems an impossible task. Each stone must have been suspended as it was intricately cut to fit so closely to the next one that even today a razor blade cannot be pushed between them.

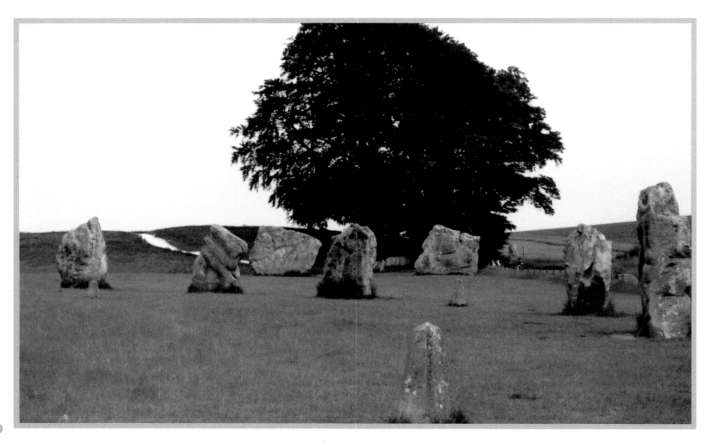

Avebury in England is the site of a remarkable arrangement of standing stones. Their purpose is still unknown, but pagans still visit the site because they say it resonates with positive energy.

Avebury, situated about 15 miles to the north of Stonehenge, was desecrated some time after AD 1300 because it was thought to house evil spirits. Today, many of the standing stones have been replaced and the village has once again become a place of pilgrimage for tourists. Like Stonehenge, its stones are said to radiate a healing energy which ties in with the theory proposed by Maurice Chatelain in *Our Ancestors Came From Outer Space*, that these "primitive" architects somehow knew how to manipulate gravity and had the power to use levitation to lift these giant stones. Does our planet hide an untapped energy source that our extraterrestrial ancestors knew how to unleash?

STONEHENGE AND AVEBURY

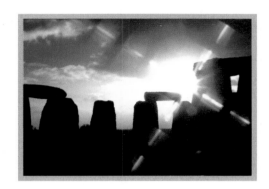

The best-preserved and most spectacular monument in Europe and perhaps even the world, is Stonehenge. Standing on Salisbury Plain in England, the traditionally accepted view is that the giant stones were moved on primitive rollers and erected using sheer manpower and ropes. Bearing in mind that some of the stones came from more than 200 miles away in South Wales and weighed $4^1/_2$ tons, this was an extraordinary feat for early man.

Not only is the construction of the site a mystery, but its purpose has also caused many debates. It is generally thought that the henge is a spectacular observatory, enabling its builders to accurately map the movement of the planets, but other researchers have linked its position to a complex of sites including the nearby Avebury, Silbury Hill, and Old Sarum, all of which are said to lie on the Earth's ancient ley lines.

BAALBEK PLATFORM

Often dubbed a landing platform for alien craft, the giant stones at Baalbek in Lebanon are an extraordinary sight. Three of the blocks are so huge that they have been estimated to weigh 800 tons each and in the nearby quarry, from which the stones are said to originate, an even bigger block has been carved which is 69 feet in length. According to Alan Alford, this giant "stone of the south" would have taken approximately 40,000 men to move it!

Although it seems an incredible proposition to us today, some researchers have speculated that ancient civilizations not only knew about electricity, but were also aware of antigravity and levitation. This theory has been particularly applied to the building of the giant monuments in Egypt, but would also seem to explain how structures like Baalbek were formed. Robert Charroux, writing in *One Hundred Thousand Years of Man's Unknown History*, said "It is not unreasonable (and it will be even less so in the near future) to suppose that extraterrestrial beings came to our planet in the distant past, that they brought their science with them, and that part of it—antigravity, levitation, parapsychology—was later forgotten or kept secret."

If this theory is followed to its logical conclusion, the sky gods would have been likely to use antigravity to power their flying machines or spaceships. If this seems a far-fetched hypothesis, then it may lend it some credence to know that NASA and other scientific establishments are currently putting huge efforts into antigravity research. Does NASA know something we don't?

Baalbek was constructed to a precise design by an unknown culture who somehow fitted 800-ton blocks together perfectly. Could this feat have been achieved with mere ropes, rollers, and flint tools?

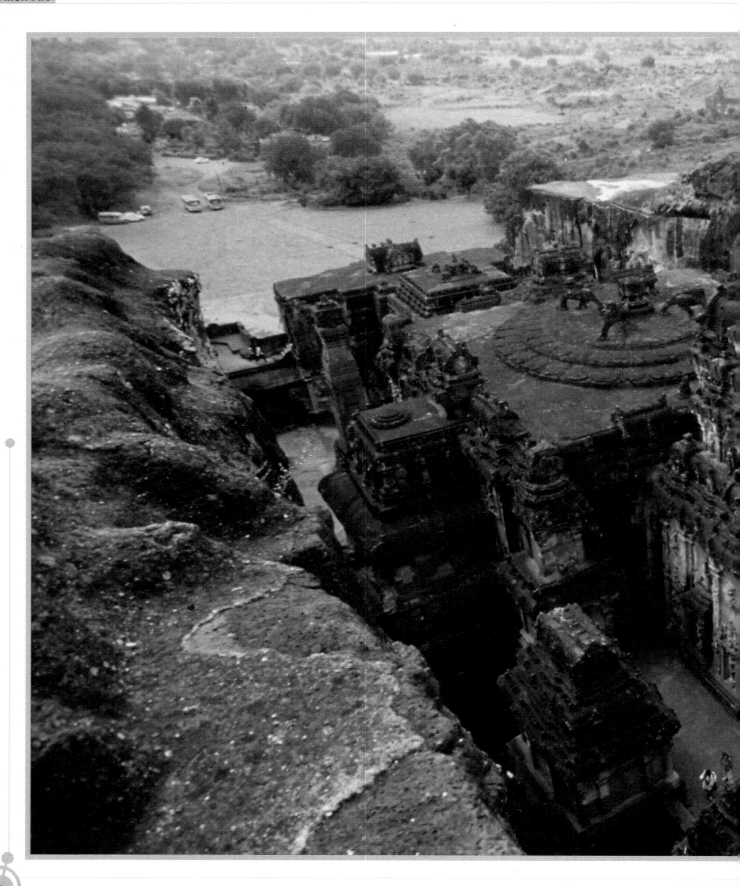

CHAPTER FIVE
ALIEN ARCHITECTURE

Some of the most impressive and technologically advanced architecture on Earth dates back thousands of years. Conventional historians have examined the great Mayan temples, the pyramids, and Angkor Wat and simply tried to establish a date for their construction, but there are many more important questions that need answering.

The sheer size and splendor of some of these ancient buildings is awesome, especially when we consider they were built by some of the first "primitive" civilizations known to man. But they are not just amazing examples of building prowess—many have intricate relationships with the star and solar systems, and some are even said to be giant beacons to light the way for visitors from above.

Despite conventional thinking, no-one has satisfactorily explained how such feats of engineering were achieved so early on in man's development. In Mesopotamia (modern-day Iraq), which is generally believed to be the site of mankind's first civilized society called Sumer, the traditional textbooks would have us believe their great cities, complete with libraries, medicine centers, sophisticated calendars and astronomical observatories, just suddenly appeared over 5000 years ago. Mankind happened to stumble across the wheel, the ability to move hundreds of tons of rock, the method of smelting metal alloys, and the creation of an alphabet.

Erich von Däniken was the first researcher to suggest that mankind might have had a helping hand at various times in its development. Since his controversial theory was publicized, other researchers have begun to question the anomalies in our ancient history. Not all of them have necessarily come to the same startling conclusion that aliens helped us become a civilized species; some simply state that we may have got our traditional chronology wrong.

Recent research shows that places such as Machu Picchu were built specifically with astronomy in mind. There was no obvious need for ancient civilizations to have such an accurate calendar system, yet the one the Mayans devised using their architectural observatories and an advanced understanding of mathematics and the solar system, is even more sophisticated than the one we use today. Why was this understanding of celestial time so important? Could it have been that their "sky gods" had promised to return? Were the observatories used as sophisticated look-out posts? Only when these amazing architectural achievements start to be examined without the trappings of conventional historical interpretation, will the truth be revealed.

The incredible architectural feat of the Kailasa Temple in Bombay, India.

MACHU PICCHU

The amazing city of Machu Picchu in Peru was only rediscovered in 1911, and it is one of the few Inca cities that the Spanish conquistadors failed to find and destroy. Hence its clues to the past are unadulterated.

The complex arrangement of dwellings, temples, and observatories are linked by more than 100 stairways. No mortar was used in the complex construction, and the site contains reservoirs and carefully constructed farming terraces.

Researcher Maurice Chatelain has written that Machu Picchu's positioning at such a high altitude and on the line of the then equator (like many other great architectural feats) was important for three reasons. First, the great ice ages had driven mankind back toward the center; second, for astronomical reasons, which the Incas certainly knew about; and third, because it "is preferable to land a spaceship near the equator than in a polar region."

Machu Picchu, traditionally thought to have been built between AD 1460 and 1470, is 8000 feet above sea level. It was almost certainly a religious center, dedicated to the worship of the Sun God Inti, and some researchers now believe that certain structures could date as far back as AD 100. If this is the case, why was such a remote site essential for such complex building work?

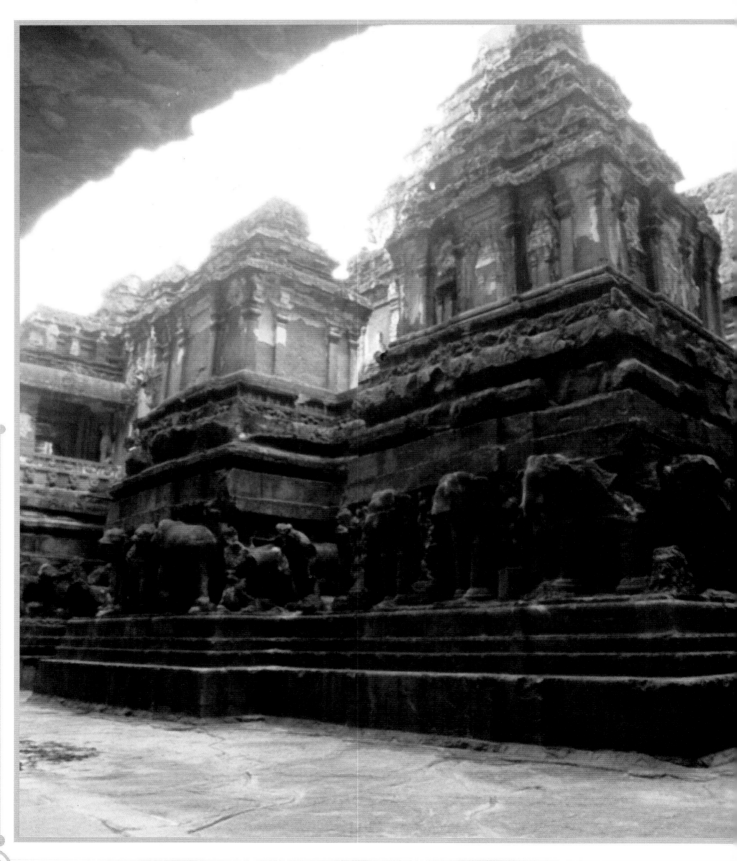

KAILASA TEMPLE

The Kailasa Temple in Bombay, India, is probably the largest building in the world to be constructed from solid rock. Carved from approximately 2,400,000 cubic feet of rock from the top down, the temple is named after Mount Kailasa, the isolated, distinctly pyramid-shaped mountain on the Tibetan Plateau which Hindu texts refer to as the center of the universe because it was the celestial abode of the god Shiva.

While the technical skill required to build the temple is phenomenal, its significance is also startling. Erich von Däniken has made much of ancient Indian texts which describe the gods coming from the sky in great chariots and flying machines (Vimanas) and that our far-off ancestors were not born on Earth, but from a star in the Milky Way. As with most Hindu temples, the ground plan of the temple floor is laid out to exact religious designs which are supposed to represent the cosmos. The relationship of the temples to the sky gods comes alive when the temples are viewed from above—which could be from where they were supposed to be seen.

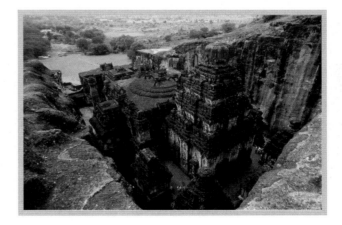

The Kailasa Temple, thought to be constructed in the 8th and 9th centuries, was originally painted white on the outside. Traditional thinking said this was to simulate the snow on the nearby mountains, but bearing in mind the limestone covering of the Great Pyramid in Egypt which some believe was a beacon for our extraterrestrial visitors, were the anonymous craftsmen of Kailasa beckoning their sky gods to return?

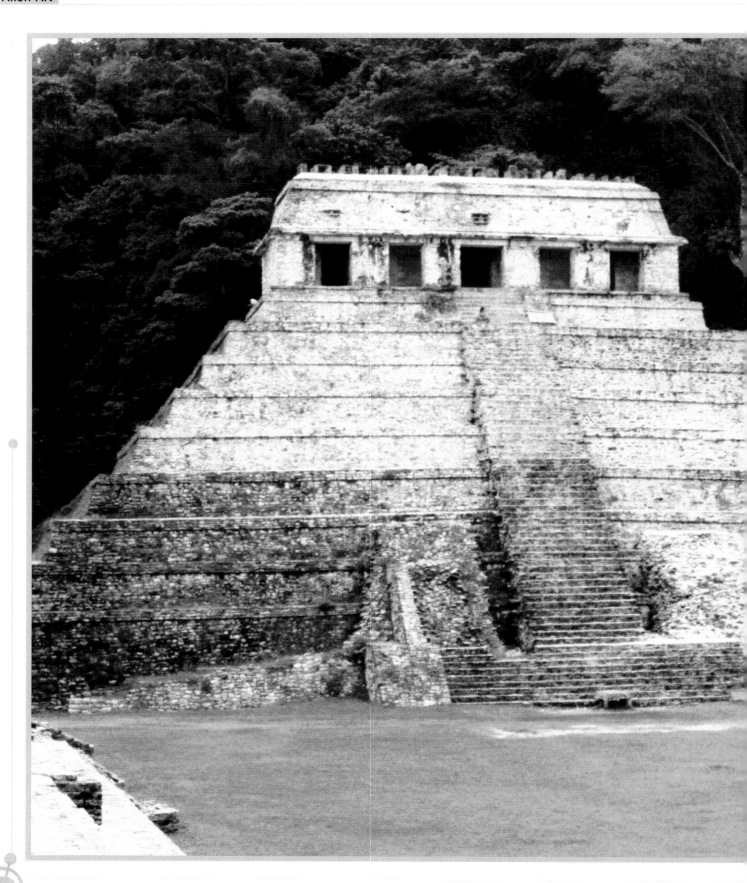

TEMPLE OF INSCRIPTIONS

The most famous of the temples at the Mayan site of Palenque, the Temple of Inscriptions withheld its amazing secret for hundreds of years until the Mexican archeologist Alberto Ruz Lhuillier discovered a secret chamber in 1952. Its excavation led to the revelation of the Palenque tomb spaceman (see pages 64–65). The construction of the temple is remarkable. Now standing at 75 feet high, it was once visible from much further afield when a 40-foot-high "comb" was intact on its roof.

These step temples were built with exact instructions from the sky gods, incorporating advanced astronomical and mathematical knowledge, as to how many steps should be built every 52 years. According to Erich von Däniken, the reason these incredibly intricate cities were simply abandoned was that the Mayans believed the sky gods would return when the buildings were complete—when the extraterrestrial visitors didn't arrive, the people lost their faith and left.

Another unsolved mystery hangs over the Temple of Inscriptions. When the secret tomb was discovered with its jade treasures, the excavators uncovered a duct that ran from the tomb up the inside of the stairs and opened at the temple floor. No-one has satisfactorily explained its purpose, but some researchers have suggested there are mystical links with similar ducts found in the pyramids of Egypt.

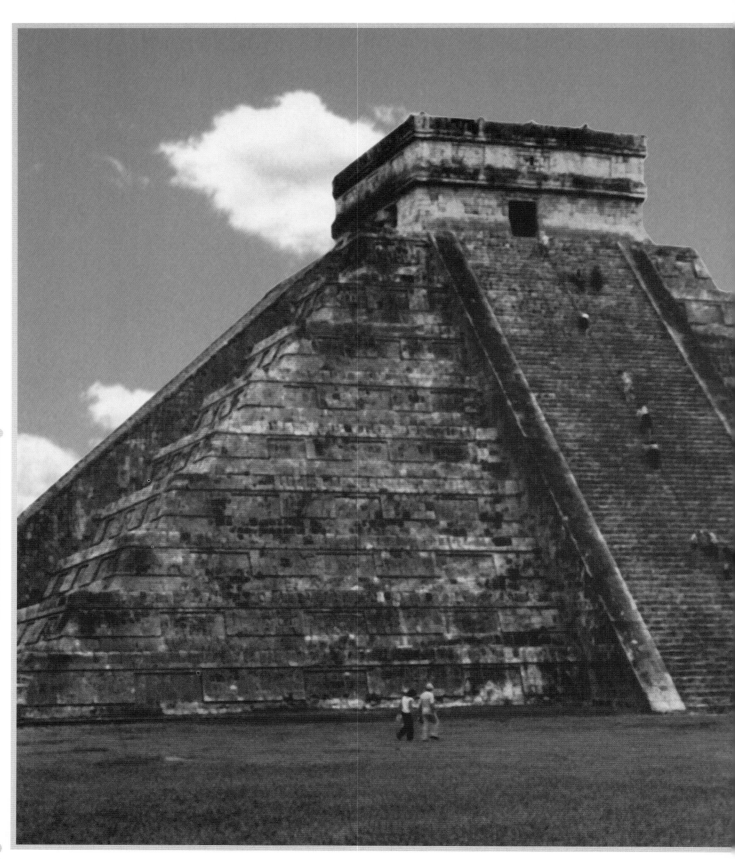

EL CASTILLO

The main pyramid at Chichen Itza in Mexico is a remarkable example of Mayan astronomical understanding, as well as giving us an insight into the mysteriously bloodthirsty gods of the later Aztecs. Ancient legends speak of a time when the sky gods allowed man to be ruthlessly hounded by wild animals, the jaguar in particular. Alan Alford has suggested that El Castillo also reflects the fear of the wild animal by dramatically depicting the serpent god coming down to Earth and then leaving: "At 5 PM on the spring and autumn equinoxes, a shadow moves down the pyramid like the rippling body of a serpent. Having reached the bottom, it then wriggles its way back to the top." This theory is supported by the shrine to the venerated jaguar inside the pyramid. If the pyramid was to prove to the gods that the people were in awe of their terrifying powers, then it did just that—not only is its relationship to the sun uncanny, but it was the scene of some of the most brutal and numerous human sacrifices in history.

Crowds still gather to watch the awesome spectacle of the serpent god emerging from the skies via the shadow of the great pyramid. Today, we think of these ancient malevolent gods as just myths, but evidence is growing that visitors from space influenced all of the major early civilizations.

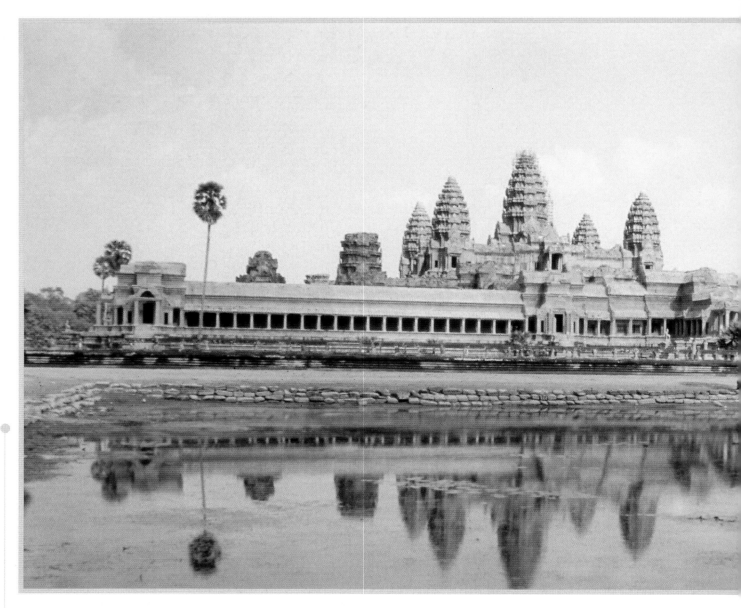

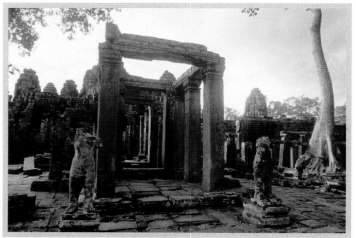

ANGKOR WAT

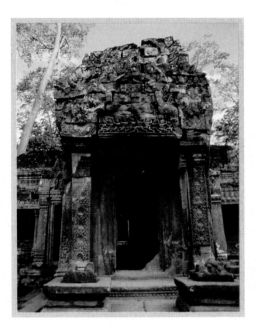

The Ta Phrom temple, part of the hundred or so buildings that still stand at Angkor, symbolizing the realm of the sky gods on Earth.

Angkor Wat was rediscovered in 1860 by French explorer Henri Mouhot who had heard tales of an ancient city built by the gods as a replica of the universe. But Angkor still remains a place of mystery, hidden away in dense jungle.

The largest temple in the world, Angkor Wat in Cambodia, which was built by the Khmer civilization in the 12th century, is said to be one of man's greatest ever architectural achievements. It was built by King Suryavarman II and has a strong connection with the Hindu temples of India. The design of the beautiful temple is said to symbolize the universe, being a physical and spiritual representation of Mount Meru where the sky gods were supposed to reside.

Like many of the architectural wonders, mystery still surrounds its existence because the Khmer people, despite the area having a complex system of reservoirs, canals, and public buildings, suddenly deserted it. For hundreds of years Angkor Wat stood silent in the midst of the jungle, the only people apparently knowing of its exact position were wandering Buddhist monks who believed the giant temple had been built by the gods—whether they were privy to the truth, or simply guessing, the temple still holds its secret inside its extraordinarily ornate walls.

THE VENUS OBSERVATORY

At the heart of the Mayan religious center Chichen Itza stands the Venus Observatory, still resembling our modern astronomical vantage points. An intricate spiral staircase winds up the inside and leads to a small observatory room with various square "windows." These viewing windows align with various stars and planets, as well as lining up with the sun's movements to plot the changing seasons.

Many researchers have begun to question why the Mayans needed such a complex and accurate calendar. The accepted view is that they needed to keep track of the months for farming purposes, but their understanding of planetary movements was so inexplicably advanced that their yearly cycles were even more accurate than our own. The Mayan astronomers observed the skies with an extreme scientific understanding. Could it have been that they were waiting for the extraterrestrial gods to return, and timing their imminent arrival?

Erich von Däniken thinks it is not such a big leap of faith to accept that these "gods" who were a central part to technically advanced peoples such as the Mayans, could well have been "real" visitors from another planet. The people themselves were convinced they were, and in light of the recent findings of possible early life on Mars, is it such a far-fetched theory after all?

The planning for such an accurate "astronomical clock" as the Venus Observatory has led authors such as Maurice Chatelain to surmise, " the scientific knowledge of astronomy shown by our ancestors tens of thousands of years ago was far superior to that of astronomers only 300 years ago." A respected NASA expert, Chatelain came to the conclusion that "it is therefore evident that our ancestors of 10,000 or more years ago possessed a level of mathematical and astronomical knowledge so superior that they could not have developed it by themselves."

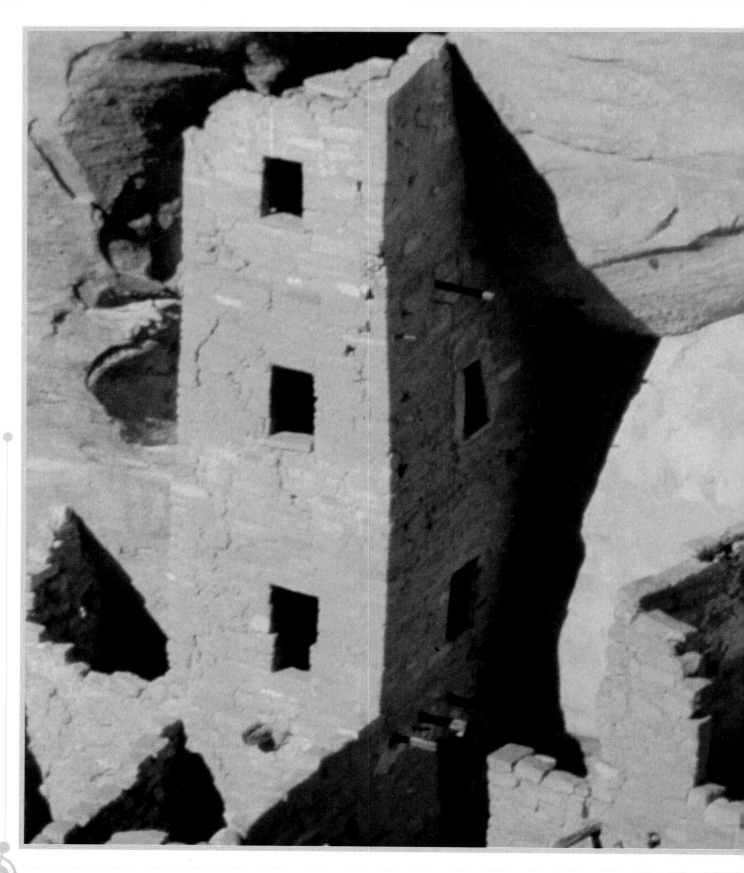

ANASAZI INDIAN CLIFF DWELLINGS

Anasazi means "ancient ones," and it is the name given by the Navajo Native American Indians to a much older civilization which existed in North America from approximately AD 1 to 1300 in the Colorado region. The Anasazi built intricately designed dwellings within which a tight community existed. Traditional Native American beliefs as to the origin of their culture focus on an ancient civilization which worshiped the sun, and many of the tribal stories handed down through generations talk of star people who came to Earth bringing great wisdom with them. Nearly every tribe tells stories of "sky ropes" that enabled these visitors to travel from their home planet to Earth.

Although very little is known about North American early history, some researchers are adamant that it dates much further back than was previously thought. Once again, in what uncannily echoes the discovery of other early civilizations, the only evidence uncovered which attempts to explain man's origins are ancient stories of extraterrestrial visitors.

A square tower house, used as an Anasazi cliff dwelling, in Colorado, USA. Some ancient Native American "myths" speak of warriors or tribeswomen being seduced by the star gods, and there are also records telling of early crop circles, which the Native Americans believed were the work of the star people.

TIWANAKU WATER PIPES

At the impressive site of Tiwanaku in Bolivia (see pages 88–91) archeologists have uncovered a complex system of reservoirs, canals, and water pipes which appear to have been even more efficient at keeping crops well irrigated than our modern techniques.

The date of the site is a major issue with historians because some feel Tiwanaku could be the first civilized society on Earth. There is very strong evidence that the Olmecs were influenced by the Tiwanaku culture.

Although more practical than "art," not everyone agrees as to the use of these elongated pipes which were sometimes carved in pairs. Erich von Däniken thinks it is far more likely that the pipes were used as containers for "energy cables" used by the gods to power their high-technology machines.

There is actually some evidence to link this unknown culture with electricity of some kind, as amongst the many relics found are intricate pieces of metalwork showing signs of soldering, smelting, and silver-plating. We know they could achieve this level of competence, but we still haven't discovered how they did it, or from where they learnt the techniques.

Tiwanaku is 15,000 feet above sea level. Many researchers have pondered why a culture sophisticated enough to build such a complex water system didn't just build their settlement near water. Perhaps the inhabitants didn't have a detailed knowledge of the area? Maybe it was the first time they had visited?

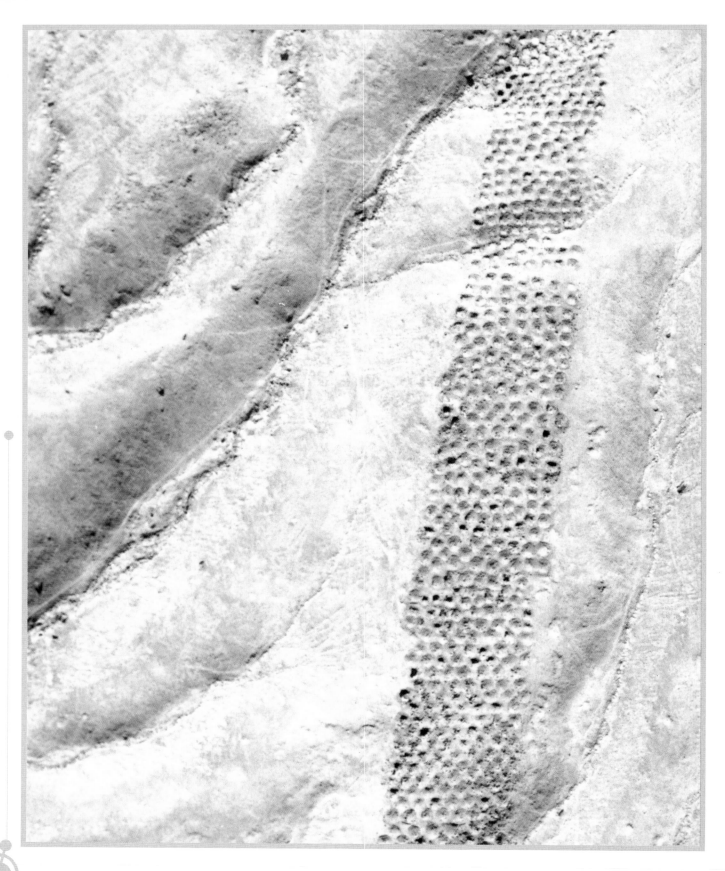

CAJAMARQUILLA

The mysterious holes in the plains of Cajamarquilla have been likened to air-raid shelters. They are roughly the proportions of a single person and no other satisfactory explanation for their existence has been forthcoming. Yet, if conventional history is to be believed then the ancient peoples had nothing to fear from the sky.

Although they are not the most visually impressive examples of the alien architecture featured in this book, the many hundreds of man-sized holes carved from the ground in Cajamarquilla, near Lima in Peru, are a fitting mystery to close on. Why they were built and indeed who built them are questions that remain unanswered. Local people tell tourists they believe they were used to store grain, but as Erich von Däniken pointed out in *Return to the Stars*, wouldn't it have made more sense to build several large storage chambers rather than so many smaller ones?

The holes symbolize so much of our planet's visible ancient history which, even as we enter a new millennium, we still don't understand.

What purpose did the holes serve? Why were so many needed? What do they mean? Who lived in this ancient culture that left a pockmarked landscape as a silent and mysterious legacy to its ancestors? Until science accepts that current understanding of our own ancient history just isn't conclusive, we cannot hope to find the real answers as to where we came from. Is it so much harder to contemplate that we may have been influenced by visitors from the skies, than we somehow evolved from an elusive missing link with monkeys? An open mind is all we need.

THE OLMECS

From 1300–500 BC the Olmecs created the first great civilization of Central America. The Olmecs had an accurate calendar system and become renowned for their artistic talents. Their influence can be seen in most early Central American art.

STONEHENGE

Northern Europe, and in particular the United Kingdom, has a plethora of ancient stone monuments, the most impressive of which is Stonehenge. Traditional history records Stonehenge was constructed from circa 1900 BC. Its use and the method of its construction are still fiercely debated.

CANADA

USA

MEXICO

GUATEMALA

COSTA RICA

BRAZIL

UK

FRANCE

TIWANAKU

In approximately 31 BC the great city of Tiwanaku was established. It became the largest center of worship in South America as well as the most important Mayan city ever. At its height an estimated 100,000 people lived in its sophisticated dwellings.

ANCIENT EGYPT

Traditionally thought of as the second earliest civilization, Mesopotamia being the first, the kingdom of Egypt is said to have been founded under Menes in 3200 BC. John West's ground-breaking new research suggests an advanced civilization existed in the area many thousands of years earlier.

CULTURAL REFERENCE MAP

To put our examples of alien art into context, it is interesting to see how our accepted view of early civilizations looks. All over our planet great cities rose up from nowhere, providing the nurturing grounds for wondrous inventions, cultivated intelligence and of course extraordinary works of art and architecture. Did these civilizations have a common bond? Perhaps an outside force who bestowed amazing technological skills on our ancestors, and then left us to "civilize" ourselves?

CHINA

CAMBODIA

EASTER ISLANDS

INDIA

EGYPT

NY

AUSTRALIA

MESOPOTAMIA

Officially classed as the first "civilized" society, the Sumerian states flourished around the rivers Euphrates and Tigris from approximately 3500 BC. Vehicles with wooden wheels were commonplace, and a written language documented everyday life.

INDUS VALLEY

In 2400 BC an independent civilization existed in the Indus Valley. They also mastered the use of the wheel, bronze, and city dwelling. The complex, brick built cities were abandoned by 1750 BC when the area was taken over by the Aryans who imposed a strict caste system.

SELECTED BIBLIOGRAPHY

Alford, Alan F.
Gods of the New Millennium
Eridu Books 1996

Bauval, Robert and Gilbert, Adrian
The Orion Mystery
Mandarin 1997

Bauval, Robert and Hancock, Graham
Keeper of Genesis
Mandarin 1997

Berlitz, Charles
Mysteries From Forgotten Worlds
Granada 1972

Blumrich, J.F.
The Spaceships of Ezekiel
Corgi Books 1974

Charroux, Robert
Legacy of the Gods
Sphere Books 1979

Charroux, Robert
One Thousand Years of Man's Unknown History
Sphere Books 1981

Charroux, Robert
The Mysterious Unknown
Corgi Books 1975

Chatelain, Maurice
Our Ancestors Came From Outer Space
Pan Books 1980

Collyns, Robin
Ancient Astronauts: A Time Reversal?
Sphere Books 1978

Collyns, Robin
Laser Beams From Star Cities?
Sphere Books 1977

Däniken, Erich von
Chariots of the Gods?
Souvenir Press 1972

Däniken, Erich von
Return to the Stars
Corgi Books 1972

Däniken, Erich von
The Gold of the Gods
Souvenir Press 1974

Delgado, Pat and Andrews, Colin
Crop Circles: The Latest Evidence
Bloomsbury 1990

Gilbert, Adrian G. and Cotterell, Maurice M.
The Mayan Prophecies
Element Books 1996

Hancock, Graham
Fingerprints of the Gods
Mandarin 1996

Kolosimo, Peter
Not of this World
Sphere Books 1973

Kolosimo, Peter
Timeless Earth
Sphere Books 1977

Landsburg, Alan
In Search of Lost Civilisations
Corgi Books 1977

Landsburg, Alan and Sally
The Outer Space Connection
Corgi Books 1975

Le Poer Trench, Brinsley
Temple of the Stars
Fontana 1962

Morrison, Tony
Pathways to the Gods: The Mystery of the Andes Lines
Paladin 1978

Shuker, Karl
The Unexplained
Carlton 1996

Steiger, Brad
Worlds Before Our Own
Star 1980

Story, Ronald
The Space Gods Revealed
BCA 1977

West, John Anthony
The Mystery of the Sphinx
A Magical Eye/North Tower Films Production

For further information on the Ancient Astronaut theory contact:
The Ancient Astronaut Society, Gene Phillips, c/o 1921 St John's Avenue, Highland Park,
Illinois, 60035-3178, USA.

The society is a nonprofit organization dedicated to the research and publication of related material.
Their membership is international and the group welcomes new inquiries.

Acknowledgments

Many thanks to all the people who have helped with this book: colleagues, friends and family.
Special thanks for help with research must go to Alan Alford, author of the remarkable
Gods of the New Millennium, Janet Bord, author and owner of the Fortean Picture Library,
Dr Karl Shuker, author, cryptozoologist and friendly advisor, Kilian Martin Bohren and
Wallace Motloch.
 I am equally indebted on a different, but essential level, to Sue Evins for all the help
and coordination.
 And last but definitely not least, David, Margaret and Richard ... you know why.

INDEX

PICTURE CREDITS

Chapter Three

Chapter Four

Chapter Five